7.95

Sandy Mather

HOW TO TAKE & DEVELOP COLOUR PHOTOGRAPHS

HOW TO TAKE & DEVELOP
COLOUR
PHOTOGRAPHS

MICHAEL FREEMAN

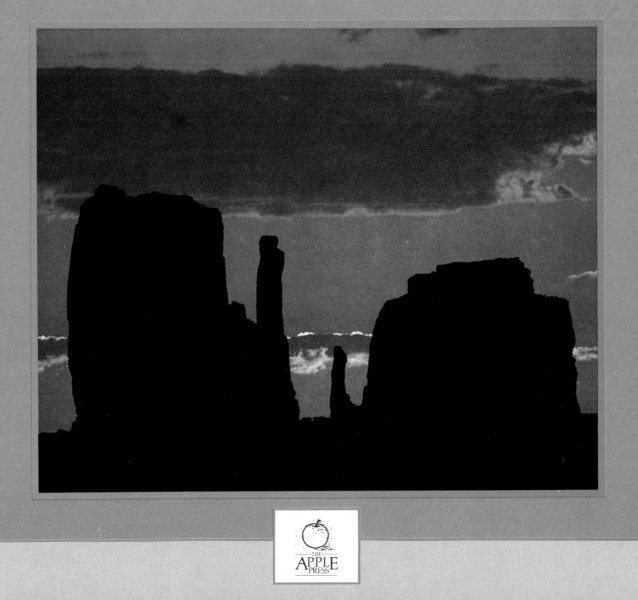

THE
APPLE
PRESS

A QUINTET BOOK

Published by Apple Press Ltd.
6 Blundell Street
London N7 9BH

ISBN 1-85076-135-3

This book was designed and produced by
Quintet Publishing Limited
6 Blundell Street
London N7 9BH

Art Director: Peter Bridgewater
Designer: Helen White
Editors: Christopher Dickie, Shaun Barrington
Photographer: Michael Freeman

Typeset in Great Britain by
Central Southern Typesetters, Eastbourne
Manufactured in Hong Kong by
Regent Publishing Services Limited
Printed in Hong Kong by
South Sea International Press Limited

C O N T E N T S

6

Colour photography has never been so well catered for and so easy to do as it is now – technically. The wave of improvements in colour films in recent years have brought high picture quality to millions of photographers with film speeds that allow handheld shooting in most of the popular picture situations, even indoors by available light. The actual chemistry of the film has been improved and simplified so that processing colour at home requires no specialist knowledge. The electronic revolution in camera design has helped to automate a great deal of the operation, freeing the photographer to concentrate on the image.

This, in fact, is the most important result of all these improvements — that they have cleared away a lot of the detail and inconvenience involved in the technical process of photography. Anything that makes it easier to use a camera must be good for photography, but only as long as photographers do not rely on the technology to make the picture. There is no mechanical substitute for good ideas and a visual sense of what looks interesting or attractive. So, with modern equipment and films more than ever, it is important to strike a balance between what the camera will do and what your eye has to see.

This book covers the essentials of colour photography, from equipment to the principles of composing with colour. Colour film processing is now so well standardized that a single type of kit will take care of nearly any film that you care to use. Certainly, it may be easier to drop an exposed roll into a laboratory for processing and printing, but one of the great pleasures in photography is to take care of the entire process, from seeing the picture through to the finished product – a slide, or a print to hang on the wall. Craftsmanship has always been an essential part of photography, and being able to keep your hands on every part of the process extends your control over the image.

BELOW Although advances in camera technology have taken much of the toil out of good photography, there is still no replacement for a great idea. In this instance, exposing for the rich sunlight has created a fine silhouette.

RIGHT A thorough knowledge of the technical aspects of photography is vital in producing good colour work. However, when all is said and done, it is the human eye and brain that judge whether a particular scene is attractive and worthy of preserving on film.

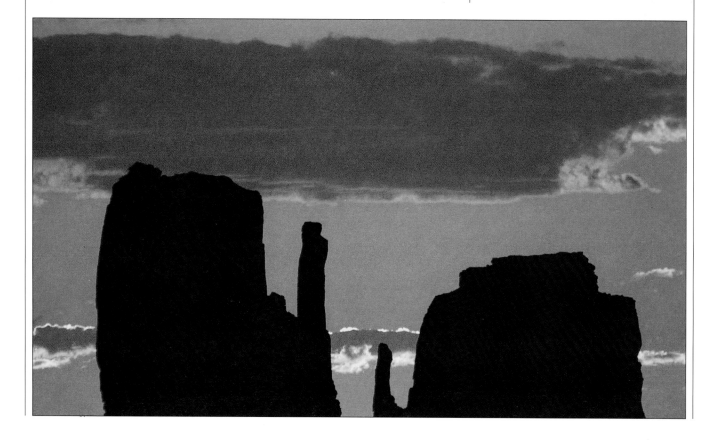

CAMERAS & LENSES

Any modern camera, even an unsophisticated snapshot model, can be used for high-quality colour photography. Nevertheless, the simpler the camera, the more limitations it is likely to have, and it is important to know from the start just what your equipment is capable of. If, for instance, it has a single fixed lens, there will be types of photography that are beyond its scope – anything that needs the high magnification of a telephoto lens, wide fields of view, or very close focusing.

This may, of course, be no disadvantage at all, particularly if you intend to concentrate on, say, candid photographs of people in everyday situations. If, on the other hand, you want to explore a variety of kinds of image and types of subject, a 'system' camera with interchangeable lenses (35mm single lens reflex) is the best choice.

As a guiding principle, tackle the areas of photography that your camera allows, or buy the equipment that your interests require. The 35mm SLR

CANON T70 This multiple program model features 8 modes of operation, is very heavily automated, and its manufacturers make a strong design feature of "computer-age" display.

MINOLTA 7000 An example of the trend towards total electronic control of all camera functions is the Minolta 7000. In particular, it features an autofocus system that is integrated into the body, so reducing the cost, size and weight of lenses.

OLYMPUS OM-4 Also a highly automated camera, the OM-4 is designed for near-foolproof operation in unskilled hands, but provides a highly sophisticated metering system for more experienced photographers.

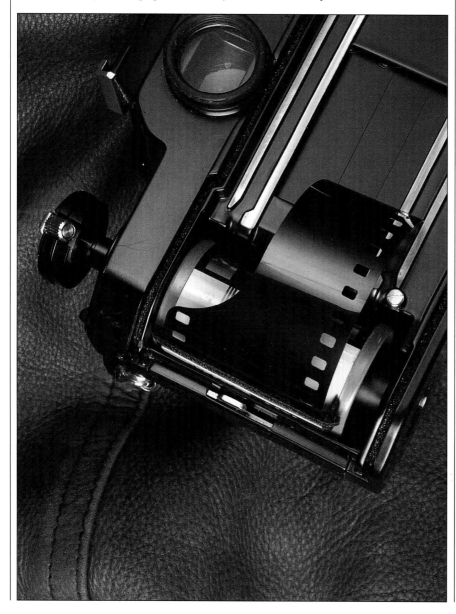

CANON AE-1 PROGRAM One of the pioneering "multi-mode" cameras, the AE-1 is a high quality camera offering both shutter priority and fully programmed automatic exposure plus full manual metering.

ROLLEI SLR 3003 Distinct from other 35mm SLRs, this Rollei model is modular in the sense of medium-format cameras, featuring interchangeable film backs and snap-on rapid recharging power packs.

NIKON F3AF One of the most advanced professional cameras, this is basically the top-of-the-line F3 with an image-displacement sensing prism. Micro motors in a small range of lenses use this information to focus the lens automatically.

camera is by far the most common type used by people who have a serious interest in photography, so in this book the assumption is that this is the equipment you are using. Most of what is written still applies to snapshot cameras and larger formats, but if you have something other than a 35mm SLR, be prepared for slight differences here and there.

Finding the balance between technical proficiency and relying too much on equipment has always been one of the hidden difficulties facing photographers. The point of this balance varies from person to person, as some photographers are more comfortable when surrounded by a large selection of lenses and other items to cope with all contingencies, while others produce their best work when using the bare minimum. Whatever the case, there are two conflicting influences. Equipment alone does not produce pictures, but the sophistication and variety available in photographic stores is an obvious temptation, as well as being a source of pleasure in what is, after all, a technically-oriented activity. Believing that a new gadget automatically will improve the standard of your pictures, however, is over-optimistic. Equally, studied ignorance of photographic technique, with the idea that only an intuitive eye is needed, is just as misguided.

Here, we look at equipment as the tools necessary for the job. No more, no less. It may help, if you are still building up your range of equipment, or are planning to start, to think of two groups of items: basic equipment and, later, extras. A data-back, for example, may appeal as an ingenious toy, but it is unlikely to be a more important purchase than a first wide-angle lens. On the next few pages, we look at the way equipment selection can work in practice. Camera design changes constantly, partly as real improvement (making automatic metering produce more consistently reliable exposures, for instance) and partly as a way of encouraging photographers to spend more money. As the function of the camera body is fairly straightforward – to move the film along, control the exposure by means of a shutter, and measure what the exposure setting should be – there are few reasons for trading in old models for new every year. Most major manufacturers produce similar ranges; if you choose no more sophisticated a model than you really need, that will leave more money in the budget for lenses, which usually merit more attention.

If you have an SLR, its two most valuable properties are that you see exactly what will be exposed onto the film (through the viewfinder), and that you can use different lenses. A first priority, then, is to have a variety of lenses, for the focal length of the lens is what determines, to a large degree, the character of the picture. Standard focal lengths, which are around 50mm for a 35mm camera, give an angle of view and proportions that appear very much as the eye sees, and this is the lens that is usually sold with the camera.

Wide-angle lenses have shorter focal lengths, take in more of the scene and give a more pronounced perspective, making close objects seem proportionately larger than those in the background. They can be used to draw the viewer into the scene and feel some sense of immediacy and involvement. At the other end of the scale, telephoto lenses have long focal lengths, magnifying the view of distant subjects, and giving a flattening effect on perspective. Mirror lenses employ a different principle to arrive at a similar effect, with a combination of lens and mirror, similar to that used in some telescopes, to achieve high magnification. Zoom lenses cover a variety of focal lengths continuously by means of a larger number of individual glass elements which move inside the lens barrel. Different models cover different ranges.

A basic selection of lenses for many people, particularly those starting in photography, would normally be a single SLR body with either three lenses of fixed focal length or one or two zoom lenses to cover a similar range. The fixed focal length lenses would be one standard, one moderate wide-angle, and one moderate telephoto. Zoom lenses have the advantage of combining the variety of focal length in a single piece of equipment, and make for a lighter load to carry around. Their disadvantages are that they are usually individually heavier than comparable fixed focal length lenses, and that the maximum aperture is smaller. (Smaller apertures mean slower shutter speeds, and make low-light photography less easy.)

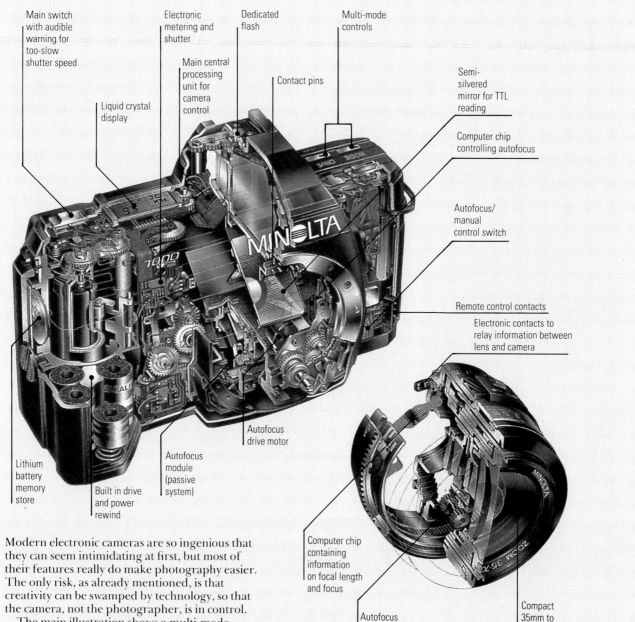

Main switch with audible warning for too-slow shutter speed

Liquid crystal display

Electronic metering and shutter

Main central processing unit for camera control

Dedicated flash

Contact pins

Multi-mode controls

Semi-silvered mirror for TTL reading

Computer chip controlling autofocus

Autofocus/ manual control switch

Remote control contacts

Electronic contacts to relay information between lens and camera

Autofocus drive motor

Lithium battery memory store

Built in drive and power rewind

Autofocus module (passive system)

Computer chip containing information on focal length and focus

Autofocus drive to lens

Compact 35mm to 75mm lens

Modern electronic cameras are so ingenious that they can seem intimidating at first, but most of their features really do make photography easier. The only risk, as already mentioned, is that creativity can be swamped by technology, so that the camera, not the photographer, is in control.

The main illustration shows a multi-mode, autofocus-capability, fully-electronic SLR camera with built-in motor drive, power rewind, dedicated flash capability and liquid crystal display.

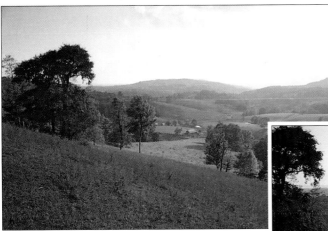

ABOVE A 28mm wide-angle lens can lend drama to a landscape scene. Depth of field is great, and even focusing becomes a secondary consideration.

Lens Effects

A good demonstration of the characteristics of lenses is to choose a single scene and shoot it using lenses of different focal lengths, ranging from very short to very long. This exercise can aid your awareness of the compositional possibilities offered by each lens.

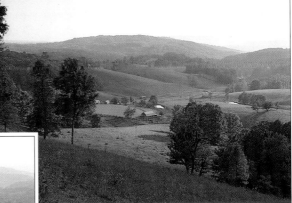

ABOVE Very much the 'standard' wide-angle, a 35mm lens still retains the characteristic of increasing the apparent distance between subjects common to lenses with short focal lengths.

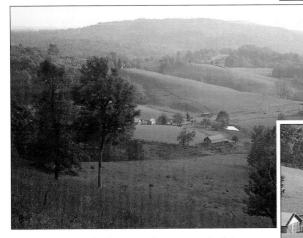

ABOVE A 50mm standard lens approximates the angle of view as seen by the human eye.

ABOVE One of the moderate telephotos, a 135mm lens enables the photographer to enlarge the subject within the frame from a distant viewpoint.

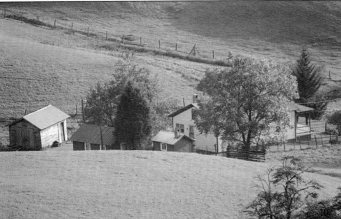

LEFT Producing good subject magnification, a 200mm lens offers a relatively small depth of field, making focusing critical.

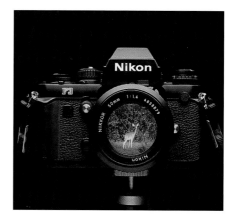

Lenses vary in the quality of their manufacture and the maximum aperture (often referred to as the 'speed' of a lens: f/1.4 is fast for a standard lens, f/2.8 quite slow). Still, the most important difference is the focal length. Think in terms of what would be the ideal range for you and your preferred subjects. The more extreme the focal length on either side of the standard 50mm, the more exaggerated the effect on the image, and the more expensive the lens. Personal taste is the only guide to follow, but the high sales of wide-angle lenses of around 28mm focal length, and of telephoto lenses around 135mm, show what the majority of people tend to choose.

Apart from focal length, other important distinctions among lenses involve special uses. Most of these, by definition, fall outside the category of basic equipment, but one is sufficiently popular to consider here. A macro lens has the ability to focus closely and give magnified views of small subjects, generally up to half life-size (normal lenses do not focus down so closely, giving a maximum enlargement of around one-seventh life-size). The optical quality of a macro lens at these close-focusing distances is, of course, high, but as this kind of lens also does a good job at normal distances, many photographers make it double up as their standard lens. Many zoom lenses have a 'macro' facility.

Angles of View

Compare the 62° angle of view of a 35mm wideangle (1) with the 46° of a 55mm standard lens (2) and the even narrower view offered by a 180mm telephoto (3).

Wide-Angle Lens

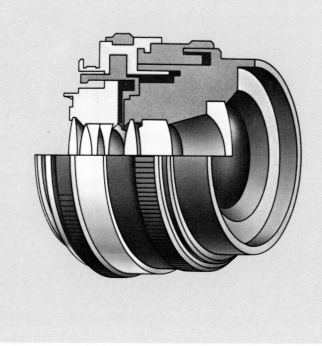

Wide angle lens. The 24mm lens (**LEFT**), with an angle of view of 84 degrees, uses a retrofocus design to lengthen its extremely short focus so that it can be used with the reflex mirror in the camera housing. To overcome the problem of poor image quality at close focusing, the elements 'float' inside the housing. Their relative positions can therefore be changed as the lens focuses closer. In use (**ABOVE RIGHT**), depth of field is relatively large while perspective is greatly exaggerated.

Standard Lens

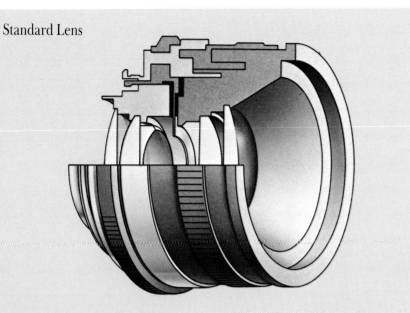

Standard lens. This 50mm standard lens presents the world approximately as the human eye sees it, giving a 46 degree angle of view that gives a 'natural' perspective and a moderately wide minimum aperture of f2 (although f1.8 maximum aperture are by far the most common on today's 50mm standards). Its six elements in four groups allow the manufacturer design flexibility to correct most common aberrations. In use (**ABOVE RIGHT**), the lens proves an ideal all-rounder, with its relatively fast maximum aperture allowing the photographer to work in low-light conditions.

Long-Focus Lens

Long-focus lens. A favourite among many photo-journalists, this fast 180mm telephoto lens has a maximum aperture of f2.8, which makes it fairly easy to hand-hold at quite slow speeds. For colour work in poor lighting conditions it is an ideal telephoto. Many lenses of this focal length tend to be heavy for their size, but this can be an advantage, as they lie steady in the hand. In use (**RIGHT**), perspective is compressed while focusing can be quite critical.

COLOUR PHOTOGRAPHY

Accessories cover the range of extra equipment beyond the simple combination of camera and lens. What counts as a necessary extra is, however, largely a matter of opinion. Some filters are a useful addition, but the most effective are those that do a basic job of altering the colour values and tonal qualities, rather than the trick effects that receive the most publicity in photography magazines. A basic set includes some light balancing filters, colour correction filters for common lighting problems (such as fluorescent illumination), a polarizing filter, colourless ultra-violet and a neutral (grey) graduated filter.

A shoulder bag is the usual way of carrying cameras, lenses, film and various odds and ends. Simple is better than fancy, because bags that advertise you as a photographer do nothing to help the picture and may even make candid photography more difficult. Choose a bag just large enough for what you need, that is, for shooting and carrying around. A large, multi-pocketed case is only useful if you have the equipment to fill it, and even then you may not find it much of a pleasure to carry for long.

One last item of basic equipment, even if you do not carry it with you constantly, is a tripod. Bulky and awkward though it may be, it is the best answer for situations that call for slow shutter speeds. A room interior shot with good depth of field, an evening landscape, city lights at night, or a close-up are examples of types of picture in which handholding will not normally do the job. Even in good light, a tripod is a powerful aid to composition, making it easier to align things exactly in the viewfinder, and, of course, add a cable release.

ABOVE A mini tripod is easy to fit into a gadget bag and can give excellent support.

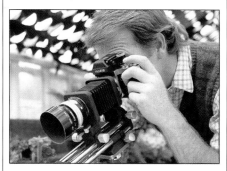

ABOVE Larger tripods, although bulky, tend to be far more flexible than their baby counterparts.

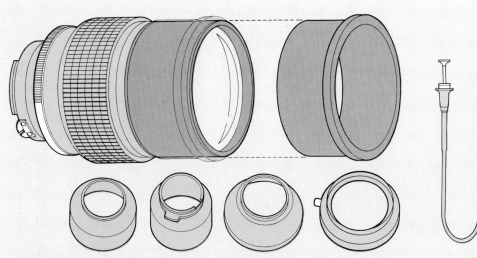

ABOVE Cable releases are an important way of reducing vibration. They come in varying lengths and can be locked during long exposures.

Lens hoods are designed to prevent flare by stopping stray rays of light from reaching the front element of the lens. As the illustration here shows, the hoods come in various shapes and lengths to suit the various focal lengths; a long hood on a wide-angle lens would result in a blacking out of a large section of the image, while a short, flared hood on a telephoto lens would not do its job at all. Although add-on hoods that screw onto the front of lenses are still widely available, built-in hoods designed for particular focal lengths are becoming ever-more common. Add-on hoods are available both in plastic and in soft rubber or a similar material, which collapses to facilitate ease of carrying.

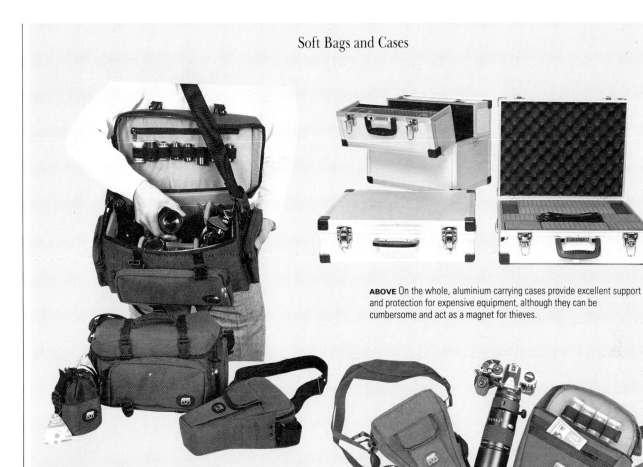

ABOVE On the whole, aluminium carrying cases provide excellent support and protection for expensive equipment, although they can be cumbersome and act as a magnet for thieves.

ABOVE A wide range of soft camera bags are available, many with an array of pockets to carry such items as film and filters, plus purpose-built pouches to hold zooms and fixed focal-length lenses.

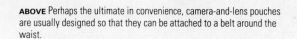

ABOVE Perhaps the ultimate in convenience, camera-and-lens pouches are usually designed so that they can be attached to a belt around the waist.

ABOVE A basic set of filters can include colour-correction, neutral, graduated, polarizing, and light balancing filters.

ABOVE PVC cases, with the same shock-absorbing filler as the aluminium cases, are less likely to attract attention.

Now that colour film development has been largely standardized to two simple processes, very little darkroom equipment is needed to process your own rolls. With few exceptions, most colour films can be developed by Kodak's E-6 process (for slides) or C-41 process (for colour negatives). Processes with different names from other manufacturers, such as Fuji, are basically look-alikes, and the differences are minor. The main exception is Kodachrome slide film which has its own process. The E-6 process requires 11 steps and 7 solutions; the C-41 family uses 7 steps and 4 solutions. These stages determine the number of containers that you will need for mixing and storing.

The basic unit for processing film is a spiral reel tank. The tank consists of a spiral reel, onto which the film is wound, and a container with a tight-fitting lid. The lid has a central hole with a lightproof baffle for the adding and pouring out of solutions, and there is usually a small cap fitted so that the entire tank can be inverted during processing. The sturdiest tanks are made of stainless steel, and many people find this type of reel the easiest to load. An alternative is a plastic tank, with a grooved reel that is loaded by sliding the film in from the edge towards the centre. More of this later, on page 100.

For removing the film from its cassette and loading it into the spiral-reel tank, absolute darkness is essential. The most comfortable space in which to work is a purpose-built darkroom, or at least an understairs cupboard, bathroom or utility room that can be light-proofed for occasional use. Shutters or black cloth blinds that run in deep recesses are the usual ways of dealing with windows, although it is easier to start with a windowless area, if you have one. Doors can be light-proofed with rubber draught-excluding strips, or with foam strips fitted into the frame. To check the effectiveness of the light-proofing, stay inside with the door closed for about 20 minutes, until your eyes have become dark-accustomed. If you can see no chinks of light anywhere, and cannot see your hand if you move it in front of your face, the darkness is probably sufficient. As a final check, take a short unexposed strip of fast colour film (pull this from the end of a fresh 35mm cassette), and lay it out in the darkness with something solid covering a part of it. Leave it there for about a minute, and then process it. When it has been washed and dried, examine it carefully for any sign of fogging; if there is any, it will be most obvious at the edge of the object that was on top of it.

If a darkroom is impractical, film can still be loaded and unloaded in a

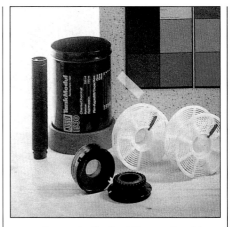

ABOVE Some tanks, like the 1500 system from Jobo, accept two different reels; in this case their 1501 reel for 35mm, 120 and 220 film, and the 1502 reel for 110.

BELOW LEFT Converted study or office: arrange developer, stop bath and fixer trays temporarily on a protected work surface, at a distance from anything that can be harmed by chemical splashes. Use a bucket, or other splash-proof container, for carrying fixed prints to wash in the bathroom or kitchen sink.

BELOW Converted bathroom: the size of the bath determines how much of the processing sequence can be carried out on the baseboard. There are unlikely to be many available working surfaces; here both fixative and wash are underneath the board. Bathrooms, when sizeable, are convenient because of handy washing facilities.

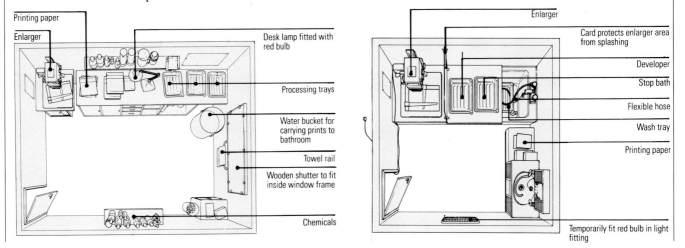

Printing paper

Enlarger

Desk lamp fitted with red bulb

Processing trays

Water bucket for carrying prints to bathroom

Towel rail

Wooden shutter to fit inside window frame

Chemicals

Enlarger

Card protects enlarger area from splashing

Developer

Stop bath

Flexible hose

Wash tray

Printing paper

Temporarily fit red bulb in light fitting

changing bag – a double-lined black cloth bag with two arm sleeves.

Other processing equipment includes graduates, clearly marked with centilitres or cubic centimetres (metric measurements have taken over almost totally from pints and fluid ounces), a thermometer, a stirring paddle to mix solutions, bottles for storing the solutions, and an effective means of maintaining the right temperature. Various brands of dish warmer are available, but a home-made alternative is a warm-water bath.

Processing equipment

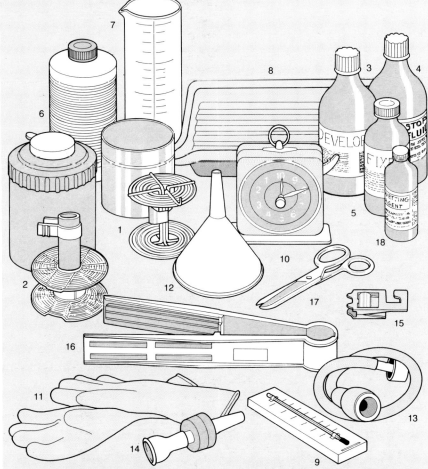

Hardboard can be used to black out windows, with clips holding it in place.

An alternative to hardboard, roller blinds are easily available and simple to fit.

Doors can be light-proofed with foam strips or rubber draught-excluding strips inside the frame.

Developing tanks are available in two basic designs – with a stainless steel reel (1), and with a plastic reel (2) which is easier to load but less durable. Developer (3), stop bath (4), and fixer (5) should be kept in clearly-labelled, light-tight stoppered bottles, an even better alternative is an expanding container with a concertina shape (6) which adjusts so that air is excluded. For mixing chemicals, a graduated measuring flask (7) is essential, and to maintain them at a constant 68°F (20°C) they should be placed in a tray (8) filled with water at that temperature, using a thermometer (9). A timer (10) can be pre-set to the recommended developing and fixing times. Rubber gloves (11) prevent skin irritation from prolonged contact with the chemicals and a funnel (12) prevents spillage when returning chemicals to the bottles. A water hose (13) and filter (14) are used for washing the film, which is then hung to dry on clips (15). Excess moisture can be removed with a pair of squeegee tongs (16). The film is finally cut into strips with scissors (17). Wetting agent (18) is added to the final wash to help the developer spread more easily and to prevent drying marks.

ENLARGING & PRINTING EQUIPMENT

If the end-product in your photography is a set of slides for projection, there is nothing more to plan in assembling the equipment. If, however, you are shooting in order to produce prints, whether from slides or negatives, a practical darkroom and considerably more equipment is needed. The main item, and the most expensive, is the enlarger. As with cameras, enlargers vary a great deal in sophistication and expense.

The simplest and cheapest enlarger that you can use for colour is, in fact, a plain black-and-white model, using its filter drawer with a set of colour printing filters (which are usually made of acetate). Make sure that the filters are the same size as the drawer; 3in (75mm) is standard. Also make sure that the enlarger is equipped with a focal length of lens that suits the film format you use: 35mm film, for example, needs an enlarger lens of 50mm or 60mm; 120 rollfilm should have an 80mm lens. Easier to use, but also more expensive, is a colour-head enlarger. The light source for this is designed for accurate colour reproduction, and the necessary filtration is built into the head. The usual system is a set of three dials or knobs, each of which turns a dichroic filter. These filters, one yellow, one magenta and one cyan (blue-green), can be dialled to different strengths. If the area where you live is subject to voltage fluctuations, a voltage regulator is useful too; otherwise, a voltage drop will affect not only the exposure (which is not too important) but also the colour balance.

On the enlarger's baseboard you will need an easel for mounting the paper. This has a means of locating the paper and adjustable masks to crop the image to the exact size and shape that you want. Focusing can often be done well enough by eye alone, but a focusing magnifier allows you to focus precisely on the grain of the film.

Other things that you will need are an enlarger timer (it is much more convenient to have this connected to the enlarger's power supply than to operate a switch yourself), a blower brush for cleaning negatives, 'dodging' tools, and a safelight, the actual filter for which depends on the type of paper you use.

ABOVE For enlargers that lack dial-in filtration, a set of acetate colour printing filters is needed. The standard set of Kodak CP filters includes the four colours cyan, magenta, yellow and red, each in four strengths (5, 10, 20 and 40), with an additional CP2B, the UV-absorbing equivalent of a Wratten 2B.

BELOW On colourheads of modern colour enlargers, such as this Durst, the three colour filters and light intensity can be adjusted through dials on the head.

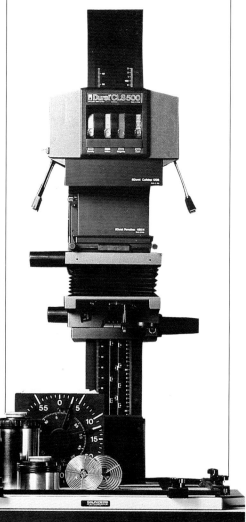

Enlarger light sources

The two alternative systems are diffusion and condenser, and each produces a distinctive quality of image. In a diffusion head, the light source is made even by a transluscent screen; in the condenser system, two lenses focus the beam. Diffusers are normally preferred for colour.

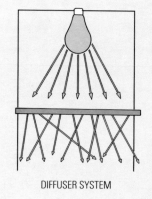

DIFFUSER SYSTEM

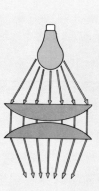

CONDENSER SYSTEM

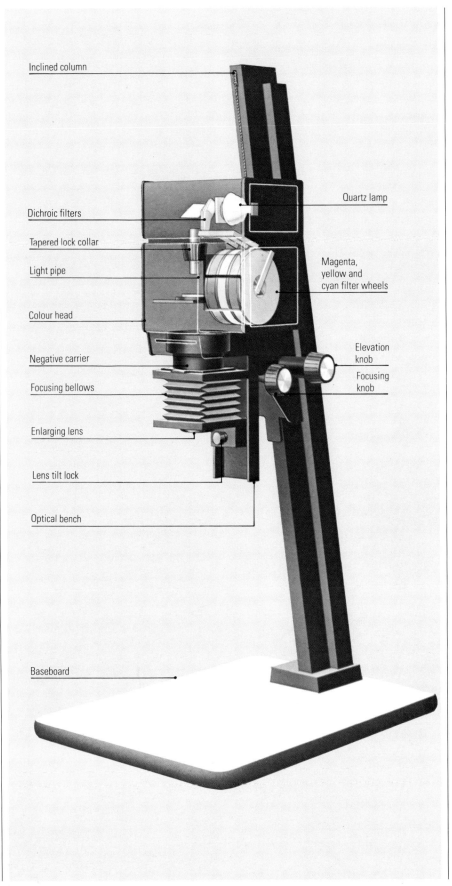

Inclined column

Dichroic filters

Tapered lock collar

Light pipe

Colour head

Negative carrier

Focusing bellows

Enlarging lens

Lens tilt lock

Optical bench

Baseboard

Quartz lamp

Magenta, yellow and cyan filter wheels

Elevation knob

Focusing knob

Enlarger with colour head

This advanced enlarger, fitted with a colour head, uses a standard quartz halogen lamp as its light source, but transmits the light through an acrylic light pipe that absorbs the ultra-violet radiation that would upset colour balance in printing. For focusing accuracy, the enlarger's fine controls are mounted on a vertical optical bench which itself is attached to the main column. The degree of enlargement is controlled by moving the whole assembly up or down on the column; the image is then focused with the bellows.

For colour printing, three dials are mechanically linked to three filters (**BELOW**) which can be placed partially or completely in the path of the light from the quartz lamp. The amount that each filter interrupts this light path determines the filtration. Less expensive enlargers use a filter drawer above the negative camera; different strengths of gelatin filters can then be inserted by hand.

Film carrier types include an adjustable mask for different film formats (1 below), a glass carrier to hold thin film flat (2), and a hinged plate (3).

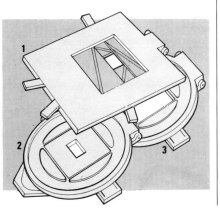

OPTIONAL EXTRAS

The equipment listings so far are sufficient to do the job, but without frills. If you are prepared to invest more, there is no shortage of extras to choose from. Some, like extra lenses or different filters, make different types of image possible. Others, like handheld meters, improve the likelihood of getting the precise effect that you want. Yet others, such as a colour analyzer for the darkroom, simply make life easier. All have their uses – it is up to the individual photographer to decide whether they are of real value.

■ EXTRA LENSES

Unless special interests take hold from the start, most photographers follow a fairly similar pattern when acquiring a set of lenses. From the standard focal length that usually comes with the camera, they move first to moderate wide-angles and telephotos (or else achieve the same result with zoom lenses that cover an appropriate range). The next step is towards more extreme focal lengths in both directions: a 20mm or 24mm wide-angle, for example, or a 500mm mirror lens. Super wide-angle lenses give not only the expected better coverage, but also introduce kinds of distortion that can be used to make strongly graphic images. Long telephotos and mirror lenses (the two constructions are different, but they both give high magnification) make it possible not only to enter specialist areas of photography, such as wildlife, but to gain access to views that are beyond the eye's ability to compose unaided.

Similarly, at very close ranges, supplementary close-up lenses, extension tubes and bellows extensions open up subjects at life-size magnification and greater – more images that are beyond normal vision.

■ METERS

The fact that more manufacturing ingenuity has gone into automatic exposure than into any other area of camera design is no surprise. Getting an exposure that makes the final image look similar to the photographer's perception has always been a prime concern. It has also been a common pitfall. TTL (through-the-lens) metering is now highly sophisticated, and works well most of the time. One thing that it cannot do, however, is to measure the light falling on the scene, irrespective of the subject. This is, in many ways, the baseline measurement, and for this reason most professionals carry and use a handheld exposure meter. If you use flash regularly, you might also want to consider an exposure meter that measures both daylight and electronic flash.

Another kind of meter, more specialized still, is the colour (or colour temperature) meter. As an extra it is probably a fringe option, but it is the one certain method of ensuring colour accuracy, or colour control, exactly as you want it.

■ DARKROOM AIDS

A colour analyzer, with its sensor placed on the enlarging easel, will recommend the filtration needed for any given negative or slide. It is, however, only really useful to an experienced printer, and so is the kind of optional extra that is best to consider at a later stage, once you have become more practised. A lightproof paper safe is another accessory that helps speed up operations: as a dispenser it saves having to open and close the box of paper each time.

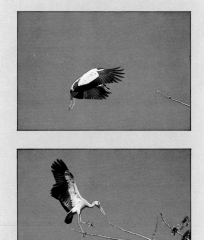

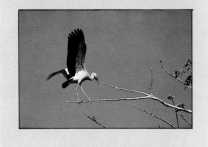

ABOVE Although motor drives are often used unnecessarily in situations where manual operation would do, for short, sharp bursts of action they have no rivals, particularly if a progressive series is the end product. Here, a motor drive operating at six frames per second reveals the flight control of an open-bill stork as it brakes to land on a branch. The pronounced flicker of the mirror seen through the viewfinder makes focusing difficult when the motor drive is in continuous operation, and it is easiest to work with subjects moving *across* the field of view.

Although built-in motordrives are becoming ever-more popular, it's still arguable that add-on motordrives both improve an SLR's handling and give greater flexibility. They are not, however, an excuse to use up film; only use the motordrive when you're unsure of your ability to catch a precise moment during action, or when you want an exciting sequence. It must be said when discussing their use, however, that the flicker of the camera's screen in the viewfinder can make focusing tricky while shooting the sequence.

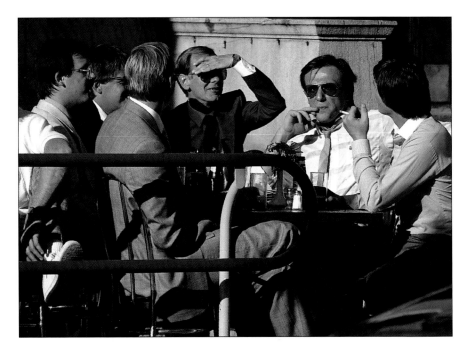

LEFT This shot of a sidewalk cafe in Montreal, Canada, features just the kind of high-contrast lighting that can fool a TTL meter. Here a hand-held meter would be the order of the day, as it would enable the photographer to measure the light falling on the scene.

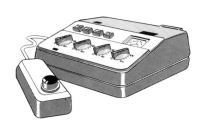

ABOVE For accurate, repeatable colour printing, an analyzer is an undoubted help. Its light-sensitive probe can measure either individual areas of the negative projected onto the baseboard, or average the range of tones.

Choosing lenses

The wider the focal length range covered by a collection of lenses, the better equipped the photographer will be to stamp his or her view of the world onto film. However, the sheer variety of lenses presently available can make the choice somewhat bewildering. By far the most important consideration when choosing is your subject matter – owning a fisheye is useless if you only shoot sports action. Shown below is a selection that could be used for general or portrait photography – a 28mm wide-angle (left), a 35mm–70mm zoom (centre) and a 135mm telephoto (right). The photographer has managed to cover a wide focal length range with just three lenses, and yet still has the advantage of the wider maximum apertures offered by the fixed focal length lenses (the 28mm and the 135mm).

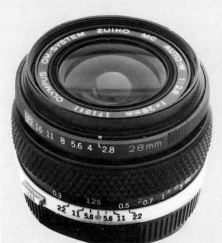
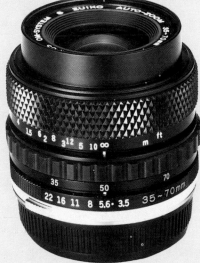
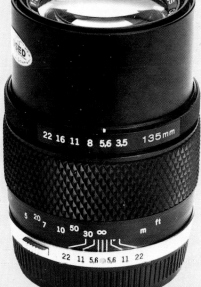

SLIDE OR PRINT?

Colour is far and away the principal medium of photography, but there remains a major choice within it. The form of the final image can be either a slide or a print, and what you do with either can itself vary, as we will see later in the book. For most people, this means either projecting the photograph in a slide show, on a screen in a darkened room or in a projection box, or displaying a print on a wall or in an album.

In making some sense of the enormous variety of colour films available – there are many different types from different manufacturers – the first step is to settle on an end-product. Although it is possible to shoot both prints and slides (alternating, perhaps, or having a second camera body to allow an on-the-spot choice) most people tend to stick with one or the other.

If you are undecided, consider the pros and cons of each. A print is the natural way of looking at any picture – it can be seen in normal lighting conditions, and is tangible. It can be mounted, framed, hung on a wall, placed in an album, or passed from hand to hand. Getting faithful colour reproduction and a full range of tones, however, takes time and skill (this, on the other hand, is part of the attraction of colour printing for many people).

One of the great advantages of slides is that, being projected by a bright light source, they appear to have considerable 'punch' – brighter highlights and a more immediate visual impact than a print. The process of photography with slide film is also simpler. As soon as it is processed, the film is ready for viewing. On the down-side, slides are not so convenient to look at. For their best effect, they need certain viewing conditions: principally, dark surroundings and a good, purpose-built screen. A slide show often has the nature of a performance, a disadvantage for some, but desirable to others in the sense of occasion that it can lend to the images.

One further point is worth considering. When photographs are reproduced in magazines, books and other print media (the term is photomechanical reproduction), the original images are usually in the form of a transparency, not a print. For professionals this is usually the overriding consideration, but there is also a growing number of amateur photographers who sell their pictures.

Mounting a print

1. Measure the picture area that is to appear when mounted, and mark the frame lines on the borders of the print in pencil.

3. On a second sheet of card – the backing for the mount – position the print and mark round the corners in pencil.

5. Apply glue to the edges of the backing card, position the top piece of card, and press down firmly.

Mounting and labelling transparencies

Make sure, above all, that transparencies are adequately protected and properly identified. Develop a system for logging in transparencies, stamping your name, copyright mark, date and description on them. If a publisher uses a transparency for reproduction – many amateur photographers are now finding outlets for their work – it will have to be removed from the mount, so be prepared to re-mount used transparencies.

© Michael Freeman 1978

INTERIOR OF MUSEO DE
BELLAS ARTES, MEXICO CITY

Mexico

2695

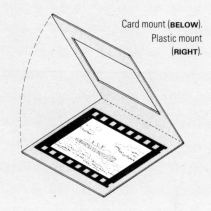

Card mount (**BELOW**).
Plastic mount (**RIGHT**).

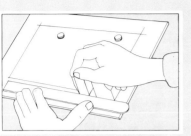

2. Mark these dimensions on the back of a sheet of thick card, and, using an angled mat cutter cut each of the lines up to the corners. Trim with a scalpel.

4. Having sprayed or brushed a light, even covering of glue onto the back of the print, roll it down onto the backing card using a sheet of tracing paper to avoid making marks.

6. The mounted print is ready for display, but handle it carefully until the glue is completely dry.

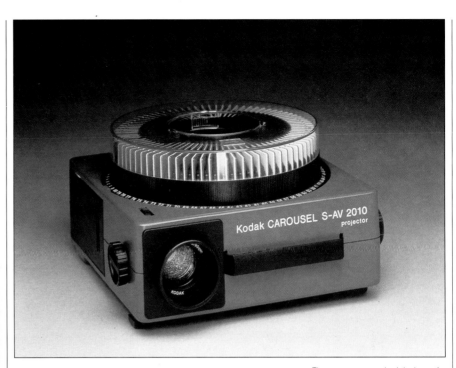

ABOVE There are two standard designs of 35mm slide projector; the revolving drum type magazine (such as this Kodak Carousel), and the sliding tray type.

A convenient filing system is to use transparent sheets, each containing individual pouches. These will fit into a standard filing cabinet.

A red spot in the lower left-hand corner of the mount (**BELOW**) facilitates assembly for projection. To signify a sequence, rule a diagonal line (**RIGHT**) across the edges.

TRANSPARENCY OR NEGATIVE?

Having decided whether prints or slides will be the final form of your photography, this does not automatically determine the kind of film you should buy. Prints can be made from either negatives or transparencies, and the different processes ensure that the resulting images have different qualities. To contrast just two examples, the visual character of prints from negatives and of Cibachrome prints made directly from transparencies are highly distinctive, and immediately recognizable to any photographer who has some experience of colour printing. Side-by-side, there is little doubt that prints from negatives have a more subtle range of tones, a broader scale of contrast, and they allow the printer more control.

Nevertheless, delicate, controlled images do not always serve the needs of photographers, and the snappy colour intensity of Cibachrome, Ektachrome RC, or similar processes may well suit the image much better. Subjects and images with rich colours and dramatic compositions often do very well printed by a positive/positive process from a slide, and images that lack sufficient contrast for your taste will also benefit. If you have slides and prefer to use a negative printing process, one alternative is to have 'internegatives' made. These are copies of a transparency onto a special colour negative emulsion that is designed to keep the contrast low (copying and duplicating on ordinary film tends to increase contrast). Unless you have experience of making internegatives, it is best to give these to a laboratory to do.

Finally, it is possible to convert negatives into slides for projection, by copying them onto a special emulsion, such as Kodak Vericolor Slide Film. Again, this is a process that is best left to a professional laboratory, and is used only occasionally.

Prints from slides

Prints made from slides on Cibachrome, Ektachrome RC or other such papers are noted for their richness of colour. Even slides that lack contrast and punch can benefit from this treatment. While some colour reversal papers are like negative papers, as their colours are formed during development, others are dye destruction papers (Cibachrome) in which already present dyes are destroyed during the processing in proportion to the projected image.

Transparency to print in one step

From an original Ektachrome transparency (**ABOVE LEFT**) a Cibachrome print (**BELOW LEFT**) was made directly. With a reputation for strong, rich colours, Cibachrome can give faithful, if slightly contrasty, results.

Prints from internegatives

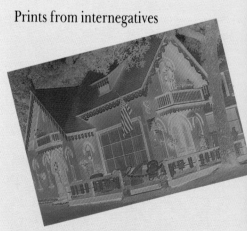

If a negative printing process from slides is preferred, internegatives can be made. Since copying and duplicating on ordinary film has a tendency to increase contrast, a special colour negative emulsion that is designed to keep contrast low should be employed when producing internegatives. Unlike the relatively new process of printing positive to positive, the more traditional technique of printing from colour negatives offers greater fine control over image values; but when contrast is high, the internegative can lose detail in the print.

Differences between reversal and negative/positive colour printing

	Reversal	Negative/Positive
More exposure	final print lighter	final print darker
Less exposure	final print darker	final print lighter
Printing-in	area is made lighter	area is made darker
Shading or dodging	area is made darker	area is made lighter
Covered edges	gives black borders	gives white borders

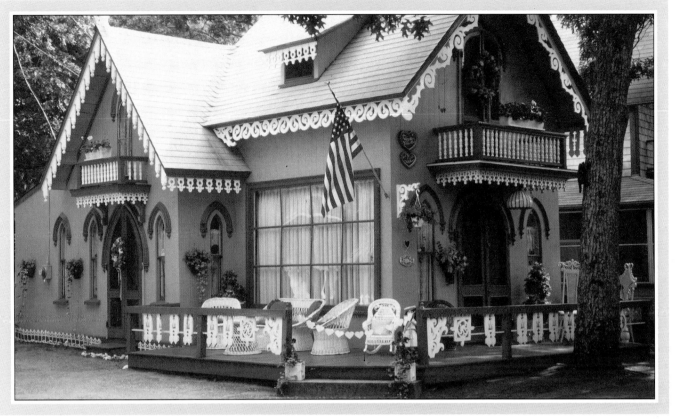

DAYLIGHT OR TUNGSTEN?

One of the eye's remarkable qualities, not shared by photographic film, is the way in which it can accommodate different types of lighting. The colour of daylight varies with the weather and the time of day, and is in all cases very different from that of domestic lighting. Yet, we rarely notice the differences. Film is more rigid in its recording of colour, and in order for scenes to appear normal in a photograph, it is often necessary to use filters or to choose a type of film that is balanced for the particular light source.

Most colour films are, naturally enough, balanced for daylight. This is, after all, the light under which most photographs are taken. What this means is that a scene photographed on a sunny day will appear to be lit neutrally: whites will photograph white, greys remain pure, without a trace of colour, and flesh tones appear natural. Daylight-balanced films are the standard, and are made to record noon sunlight (5500K on the colour temperature scale on page 36) as white.

There is, however, another type of film, balanced for tungsten lamps which have a colour temperature of 3200K. This is much more orange than sunlight, as you can check for yourself by shooting an indoor, tungsten-lit scene with regular daylight film. Nearly all tungsten-balanced films are known as Type B. Type A, which is balanced for slightly less orange 3400K lamps, is now almost obsolete; a Type A Kodachrome is available in some countries.

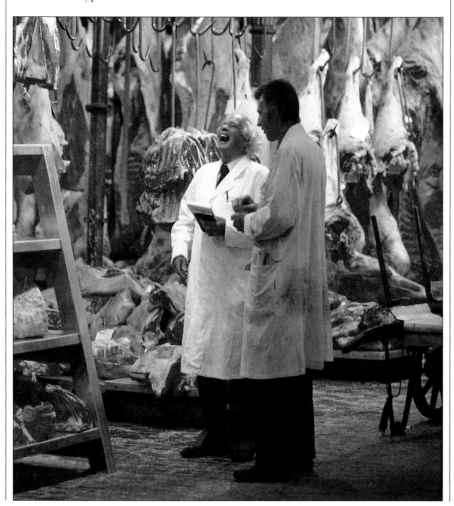

LEFT This picture was taken on daylight film; the mixture of natural and tungsten light has given a slight orange cast to the meat. But it is precisely the richness and warmth of colour which gives the image its point, so why filter?

The reason for the existence of tungsten-balanced films is not candid indoor photography, but the fact that in the past all studio photography was done with incandescent lamps. Being brighter (hotter) than ordinary domestic tungsten lamps, these burn whiter. Nowadays, although incandescent photographic lamps are still used, electronic flash is the most popular photographic light source, and this is balanced to the colour of daylight.

Under most circumstances, therefore, daylight-balanced film is the natural choice. Type B film, however, is still remarkably useful. Apart from matching photographic lamps, it partially corrects the very orange cast from domestic tungsten lamps. If the effect that you are looking for does not really need to be perfectly neutral, Type B film may well be sufficient alone, without further filtering.

Another use for Type B film is for long exposures. The reason lies in 'reciprocity failure', which is described on page 33. Low light, or the need for very small apertures to give good depth of field, makes longer exposure times necessary. At slow shutter speeds, typically 1/10sec and longer, films behave as if they were slower (less sensitive), and colour films acquire a colour cast (this colour distortion varies according to the make of film). Because Type B film is specifically designed for work in the studio where a tripod is normally used, its optimum exposure is much slower than that of daylight film. Even in daylight therefore, Type B film with an appropriate orange filter (85B) will actually give truer colours in a long exposure.

BELOW Two photos that show perfectly the problems and solutions encountered when working with tungsten lighting. One (**RIGHT**) shows the strong orange tint that results from shooting on daylight film a scene that is predominantly lit by tungsten (the household lamps in the background). The other photo (**LEFT**) has a far more natural look, the result of using tungsten-balanced film. An alternative is to use a blue filter.

SLOW OR FAST?

Film speed and graininess are inextricably linked. If you choose a fast film because it will be easier to use in low levels of lighting, the image will be more grainy and so show less detail. If a grain-free image is important, you must choose a slow film. The reason for this is that, like basic black-and-white film, colour emulsions rely on silver grains to form the image. During the processing, these are replaced by coloured dyes, but in the early stages of making a picture, silver halides are converted to black metallic silver. One of the basic methods of making a film more sensitive to light is to use larger grains, and this naturally affects the quality of the image.

In fact, the speckled texture of 'graininess' is not the individual grains, but clumps of them overlapping each other in the emulsion. To the eye, however, the explanation does not matter; the fact remains that graininess intrudes on the image. Now, whether this appears to spoil the image or not is entirely a matter of taste, just as some painters try to avoid brushmarks and the thickness of the paint from being obvious, while others use the textures to help the picture. On balance, most photographers aim for a grain-free result; using grain when you want it is fine, but having it unavoidably is annoying.

Film speed is measured in standard units designated by the initials ISO (International Standards Organisation). Strictly speaking, the number is in two parts, equivalent to the old ASA and DIN ratings, and looks like this: ISO 25/15. In normal use, however, the last figure, which is the DIN equivalent, is usually dropped. Although films could be made in any speed between single digits and over ISO 1000, in practice the film manufacturers group them. The speed groups are slow, between ISO 25 and ISO 50; medium, between ISO 64 and ISO 100; fast, between ISO 200 and ISO 400; and ultra-fast, over ISO 640. Within these groups, there is a choice of brands, most of them very similar in performance in the very competitive film market.

Photographers' tolerance of graininess varies, and one of the main factors is the degree of enlargement. There is little point worrying about it if the prints you make are all postcard-sized. If they are larger graininess begins to show, particularly on fast films, and larger prints will show it even more.

ABOVE Slow films (ISO 100 and under) are perfectly suited to still life work, where a photograph's ability to show detail is all-important.

LEFT As a general rule, slower films display richer, more vibrant colours than their faster counterparts, and will always give sharper results.

LEFT While an increase in grain is an unavoidable consequence of using fast films, the photographer who produces small prints may not find the trait a problem.

BELOW With faster films, the larger the print, the more noticeable the grain. At 10×8in, graininess begins to show, and larger prints will show it even more.

Finally, having narrowed down the categories of film, there remains the choice of brand. There are now more than ever, and the choice is made no easier by conflicting manufacturers' claims and by photographers' prejudices, which sometimes are unreasonable. From the start, it is as well to bear in mind one essential fact: the differences between most brands are minute. This depends, naturally, on comparing like with like; in particular, as we have just seen, the film speed makes a noticeable difference.

This may seem to be a sweeping statement, and it is, but intentionally so. If we subjected a group of different makes of film to laboratory tests, using a microscope to measure graininess and resolution, it would be possible to distinguish between them. Realistically, however, this is not the way that photographs are enjoyed. There are basically two ways in which one manufacturer's emulsion differs from another's. The first is in the technological edge that one may have: slightly better graininess for a given film speed, for example. Such leads, however, are often measurable only in very small percentage points, and the rival manufacturers normally catch up before too long. The second area of difference is in the priorities that film makers give to certain colours. Colour film attempts to reproduce the entire range of hues in nature with just three layers of coloured dye. This is actually an impossible task, but the major film companies come extremely close. Even so, depending on the choice of dyes or filters built into the emulsion, it is possible to pay special attention to, for instance, the blue of a clear sky, or to the naturalness of flesh tones, or to the neutrality of greys. If these are the priorities, other colours often do less well.

Now that film processes have become standardized, it is not surprising that most E-6 films, for example, look similar. They do, after all, share similar chemistry. The same applies to C-41 process films, but the extra step of printing introduces such a big variable that it is harder to discriminate.

One process that does stand apart is Kodachrome. This patented Kodak process for slide films is quite different in that the coloured dyes are added during the processing. As used by the photographer, Kodachrome is actually a black-and-white film. The advantage of this is that the film can be thinner, and so the resolution higher and graininess less. Kodachrome 25, the slowest of the family, is widely regarded as the benchmark slide film. Because the film can be processed only at a few locations, Kodachrome is not convenient for everyone.

Comparison film tests are occasionally run in photography magazines, and these are always worth reading. Ultimately, however, the only thing to do is to make your own comparisons.

To take a large number of films is impractical; instead, choose a category of film speed (slow, medium, fast or ultra-fast) and select three or four brands. Shoot identical scenes on each, rewinding the films after a few frames and reloading if you have only one camera body. Do not expect to see major differences, but make your choice subjectively. Then follow the professionals' advice: stick with that film and become thoroughly familiar with its behaviour.

RIGHT (top to bottom) Kodacolor Gold (available in ISO 100, 200 and 400) was Kodak's answer to consumer demand for more colourful prints. Kodachrome 64 is very popular among professionals, and is seen by many as a 'benchmark' for slide emulsions.

The right film for the right subject

By shooting the same scene on a variety of films and studying the results side by side, subtle differences can be spotted which would otherwise go unnoticed. For everyday use, almost all of the brands would be acceptable, but there are variations in sharpness, overall colour balance and graininess which can be used to advantage in particular situations. Most films are designed to reproduce *certain* colours well, and photographers will select film based on its intrinsic characteristics and their particular needs for the shot. For example, one manufacturer may aim for a rich blue – good for seaside shots or holiday brochures – and another instead for accurate reproduction of flesh tones.

Type of film	Brand examples	Best uses
VERY FINE GRAIN DAYLIGHT ISO 25	KODACHROME 25 AGFACHROME 505 FUJICHROME 50	Static or slow-moving subjects, and when detail is important, eg architecture, landscape, still-life, studio subjects.
FINE GRAIN DAYLIGHT ISO 200	KODACHROME 64 FUJICHROME 100 EKTACHROME 100 AGFACHROME 100	General use: the standard films for all except fast action and dimly lit subjects.
MEDIUM-FAST DAYLIGHT ISO 200	EKTACHROME 200 AGFACHROME CT200	Compromise film, giving better grain than the fast films but a speed advantage over standard films. Good for some candid street photography.
FAST DAYLIGHT ISO 400	EKTACHROME 400 3M COLOUR SLIDE 400 FUJICHROME 400	For low light and fast action, eg at dusk, in fluorescent-lit interiors (with f1 filter), sports.
SUPER-FAST DAYLIGHT ISO 800-1600	EKTACHROME P800/1600 FUJICHROME 1600	For extremes of low-lighting and fast action. P800/1600 is variable in speed from ISO 400 to 1600 and is becoming the standard fast film for many professionals.
FINE GRAIN TUNGSTEN-RAI ANCED ISO 40-50 AGFACHROME 50L	KODACHROME 40 EKTACHROME 50 AGFACHROME 50L	For static interior (tungsten-lit) and studio subjects.
MEDIUM-FAST TUNGSTEN-BALANCED ISO 160	EKTACHROME 160	Moving indoor (tungsten-lit) subjects, especially if lit with photographic lamps. In television studios and on film sets.
FAST TUNGSTEN-BALANCED ISO 640	3M COLOUR SLIDE SHOT	Candid photography in tungsten-lit interiors. Alternative: super-fast daylight film with 80B filter.
RE-PACKAGED MOVIE STOCK	EASTMAN 5247 EASTMAN 5293	Transparencies and negatives from same film stock. Colour balance unimportant. Good for uncertain conditions.
INSTANT FILM	POLACHROME CS	For testing or when slide is needed immediately.

KODACHROME 25

KODACHROME 64

EKTACHROME 64

EKTACHROME 200

EKTACHROME 400

FUJICHROME 400

FUJICHROME 100

AGFA CT 18

AGFA CT 21

COLOUR ACCURACY

In looking at different brands of film, we have already touched on the problems of reproducing colours accurately. What makes colour photography possible at all is the convenient fact that three primary colours, mixed in the right proportion, give a fair approximation of most other colours. They can even give an exact rendering of some, but not of all at the same time, at least not with the current state of the art in film technology.

Most of the time, colour accuracy is not an issue. It does become important with two kinds of colour: a group of hues to which photographic film behaves strangely, and what are known as recognition colours.

The first group includes dyes and surfaces that reflect strongly (but invisibly) in ultra-violet, far red and infra-red. Examples are blue morning glory flowers, and organic fabric dyes, particularly in dark green textiles.

The second set of hues, recognition colours, are those that the eye discriminates more sensitively than it does any others. They include grey, which is really an absence of colour, and very familiar ones, such as skin tones and the blue of a cloudless sky. Even a slight departure from an accurate version instantly looks wrong. A painted barn could be virtually any colour at all in a photograph, yet a viewer would know if it were accurate only by holding the picture up against the real barn. A person's face, on the other hand, is an entirely different case: a pale complexion is already a delicate blend of hues, so that just a touch extra of green, say, or yellow, can make the subject of a portrait look ill!

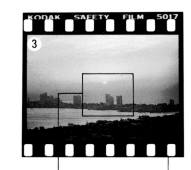

ABOVE The pale image, weak shadows and green colour cast typical of film used long after the expiry date marked on its box.

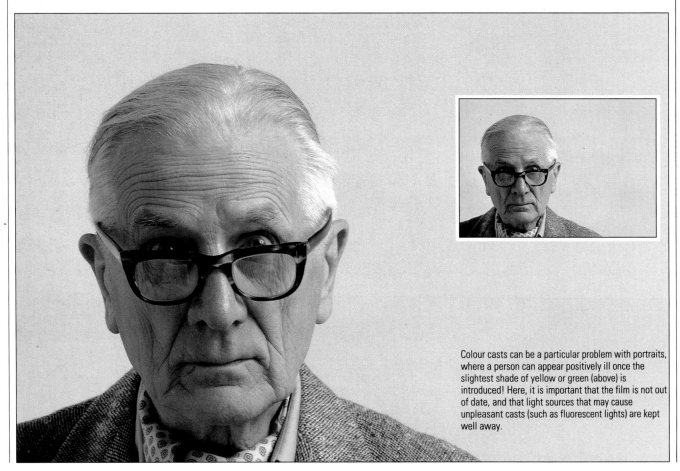

Colour casts can be a particular problem with portraits, where a person can appear positively ill once the slightest shade of yellow or green (above) is introduced! Here, it is important that the film is not out of date, and that light sources that may cause unpleasant casts (such as fluorescent lights) are kept well away.

These are the inherent problems of colour photography that the film maker has to face, and generally they manage well enough. The main reasons why a photographer occasionally finds a colour cast over the image are that the film may be old, stored badly, or that a long exposure has caused a shift in the colour layers. When film ages, it turns towards one colour, often green, because the three colour layers in the emulsion become less sensitive at different rates. Long exposures cause a similar effect: the reciprocity between aperture and shutter speed (for instance, increasing one and decreasing the other by the same amount should give the same exposure) no longer works. The film becomes less sensitive at long exposures, but the three colour layers react slightly differently. Hence there is a colour shift.

LEFT AND ABOVE LEFT The danger with long exposures is that the reciprocity law between shutter speeds and apertures may be broken, resulting in a strong colour cast (left). It is possible to compensate for this, and most manufacturers can supply instructions as to the exact exposure adjustment required.

BELOW AND BELOW LEFT A photo that may have taken ages to set up can often be ruined by the use of out-of-date film. Compare the photo taken using good stock (left) with the picture displaying the green cast, taken on aged emulsion (right).

Film always needs special care; it is more delicate than any piece of camera equipment, and can easily be damaged by poor storage and careless handling. Colour film is more susceptible than black-and-white, as its colour balance depends on three layers of emulsion each being in perfect condition.

KEEPING FILM

The main precaution to guard against is ageing, which is accelerated by high temperature and humidity. In general, keep all unprocessed film cool and dry, and process it as quickly as possible. The best conditions for storing are below 16°C (60°F) with a relative humidity between 40 and 60%. For long-term storage, 4°C (40°F) in a refrigerator is ideal, while a freezer set at −18°C (0°F) will virtually halt any ageing. However, when you take the film out of really cold storage, do not open the film can immediately, but give it time (up to an hour if it has been in a freezer) to warm up gradually. Otherwise, condensation may form on the emulsion. Try not to keep film longer than the date marked on the packet, unless you freeze it as described.

If you are travelling with film, these conditions are not usually possible. In hot weather, a good alternative is a styrofoam picnic box, but in any case, keep the film out of direct sunlight, both to avoid overheating and to lessen the risk of light leaking onto the edges of the film (this is more of a risk with 120 and 220 rollfilm than with 35mm). If the weather is humid as well, pack a sachet of silica gel crystals, which absorb moisture; if film suffers from too much humidity, the emulsion becomes soft and swells.

X-RAYS

Security checks at airports are an unavoidable aspect of travelling with cameras and film. X-rays can fog film, and the effects are very similar to the fogging caused by light, but the doses given by most airport machines are too low if the film passes through only once. However, after several flights and X-ray checks before each one, then there is a real risk, particularly with high-speed colour film. Keep your film with you in your hand luggage and ask for an inspection by hand. In the United States and some other countries, you are entitled to this by law, but in most you have to rely upon the goodwill of the security staff. Lead-lined envelopes can be bought at photographic stores, but they are best as an emergency safeguard rather than as a regular procedure.

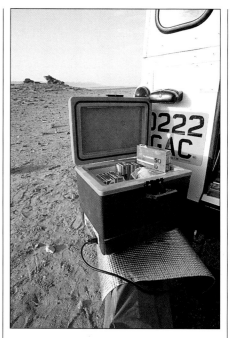

ABOVE A mobile refrigerator or electric cool box is ideal for keeping films cool on location. Unprocessed films should as a rule be kept at temperatures below 16°C (60°F), while a freezer set at −18°C (0°F) should halt virtually any ageing. Even a styrofoam picnic box can prove a useful tool in keeping film cool.

Visual density change in a film to one MR dose of x-rays (based on Eastman Kodak Data)		
	Density change	No. of passes needed to produce visible effect
Kodacolor 400	0.013	One
Ektachrome 400	0.011	One
Ektachrome 160 (tungsten)	0.006	Two
Ektachrome 200	0.005	Two
Kodachrome 64	0.005	Two
Kodacolor 100	0.004	Three
Kodachrome 25	0.004	Three
Tri-X	0.002	Five
Note: The smallest *Noticeable* change is about 0.01		

LEFT While there remains debate over the extent of the damage caused by X-rays, there is no doubt that professional films in particular can be ruined by exposure to them. This chart shows the visual density changes in films caused by X-rays.

■ LOADING AND UNLOADING

Develop a set procedure, and do not rush. The greatest danger in loading is when the film tongue does not fit firmly in the groove of the take-up spool; check that the film is running by watching the rewind knob as you wind the film on each time – it should move. Having loaded the film, check that the film speed dial on the camera has been set correctly. Always load and unload in subdued light – at all costs out of direct sunlight. Remember that you can tell whether a camera contains film by twisting the rewind knob; you will feel tension if it is loaded.

Loading

1. Open the camera back and pull out the rewind knob. In subdued light insert the film cassette so that the protruding end of the spool is at the bottom. Push back the rewind knob.

2. Pull out the film leader, and by rotating the take-up spool insert the end of the film into one of the slots, making sure that the perforations engage the lower sprocket.

3. Wind on the film until the top row of perforations engage the upper sprocket and the film is tensioned across the film guide rails.

4. Close the camera back and gently turn the film rewind knob in the direction of the arrow until you feel resistance. This is to check that the film is fully tensioned.

5. Advance the film two frames, making two blank exposures. The frame counter should now read "0". Advance the film one more time and the first frame is ready for exposure.

6. Tear off the end of the film carton and place it in the holder on the back of the camera to remind you what type of film you are using.

Unloading

1. Press the rewind button. Unfold the film rewind crank and rotate it in the direction of the arrow. Continue to do this until you feel the tension ease. This indicates that the film has been fully rewound.

2. In subdued light, open the camera back. Pull out the rewind knob and take out the film cassette.

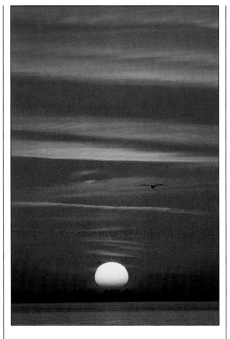

ABOVE The reddish light from a sunset is expected, and compensating for the colour cast with filters would make the scene look unnatural.

Mired shift values for Kodak filters

FILTER (yellowish)	SHIFT VALUE	APPROX. F-STOP INCREASE
85B	+131	⅔
85	+112	⅔
86A	+111	⅔
85C	+81	⅔
86B	+67	⅔
81EF	+53	⅔
81D	+42	⅓
81C	+35	⅓
81B	+37	⅓
86C	+24	⅓
81A	+18	⅓
81	+10	⅓
FILTER (bluish)	SHIFT VALUE	APPROX. F-STOP INCREASE
82	−10	⅓
82A	−18	⅓
78C	−24	⅓
82B	−32	⅓
82C	−45	⅔
80D	−56	⅔
78B	−67	1
80C	−81	1
78A	−111	1⅔
80B	−112	1⅔
80A	−131	2

Both daylight and tungsten lights have what is known as colour temperature. This is a measure of the bluishness or reddishness of light expressed in degrees of temperature (Kelvins, which are similar to centigrade, but begin at absolute zero). Bluish light, as from a clear sky, has a high colour temperature; reddish light, like that from a low-wattage lamp, has a low colour temperature. Noon sunlight, for which daylight-balanced film is calibrated, is 5500K.

What makes colour temperature critical in photography, particularly indoors and in open shade outside, is that the eye quickly adjusts to differences. Film simply records what is there. The table shows the range of normal conditions, from candlelight to a deep blue sky. In ordinary pictorial photography, there are often no adjustments needed: a reddish sunset is expected and normal. On occasion, however, the colour cast can look inappropriate, such as a portrait taken under a blue sky in the shade of a building (the result will be too blue). Then, the answer is to use light-balancing filters over the lens, and in extreme cases of red/orange lighting, to switch to Type B film.

Calculations are often more convenient to make in the form of mireds (micro reciprocal degrees). These are the equivalent of one million divided by the Kelvin number, and are easier to use because they can be added and subtracted but stay constant. The table shows how they relate to filters, each of which has a mired shift value. Bluish filters (Kodak's 80 and 82 series) raise colour temperature and have negative mired values; straw- and orange-tinted filters lower the colour temperature and have positive mired shift values. For instance, if you were using Type B film, balanced for 3200K (312 mireds), but shooting by the light of a domestic lamp that gave 2900K (344 mireds), the way to correct the effect would be to use a filter with a value of minus 32 mireds – in other words, a Kodak 82B or equivalent from another manufacturer.

Outdoors, the combination of a midday sun and some surrounding blue sky gives about 5500K, for which daylight film is balanced, and which appears 'white'. Earlier and later in the day, the sun is lower and some of its shorter, bluer wavelengths are scattered by the atmosphere, making it more yellowish, orange and sometimes even red. Out of the sun, a blue sky has a much higher colour temperature, 10,000K and higher. Clouds, if continuous, usually raise the colour temperature slightly, perhaps to about 6000K, which is why a slightly warm-tinted filter, such as an 81B, can be useful.

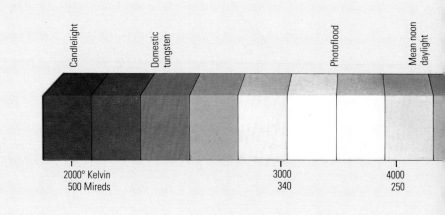

Indoors, tungsten lamps have more predictable colour temperatures, as the table shows. Judging the colour temperature is difficult at first, but it is usually enough to know the approximate values.

SUNLIGHT

There is a wonderful variety to natural light, and knowing something of its ingredients and how they interact makes it possible to use daylight for photography with confidence. It is almost impossible to control (except on a small scale), but you can anticipate it, which is the next best thing. The two factors which control the quality of daylight the most are the position of the sun and the amount of diffusion by clouds, mist or haze.

The height and angle of the sun depends on the time of day, the season of the year, and on the latitude (it is highest in the tropics). On a latitude in the United States or most of Europe, there is a big difference between summer and winter. In the summer, the sun is high by mid morning, and stays at its brightest until mid afternoon (once the angle of the sun is over about 40 degrees, it is fairly constant). In mid-winter, the sun never reaches even this height.

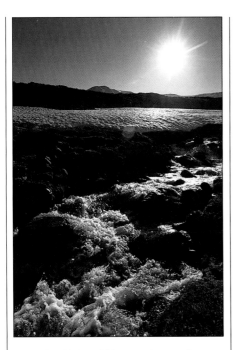

ABOVE As with the reddish sunset shown on the opposite page, the bluish light from a clear sky is to be expected and accepted as a natural part of the picture.

RIGHT Unlike the reddish sunset light, the orange cast achieved when using tungsten lighting while shooting on daylight-balanced film can have an unpleasant and undesirable effect.

BELOW From the reflected light of a blue sky at this end to candlelight at the other end, this scale covers the range of colour temperatures most likely to be met in photography.

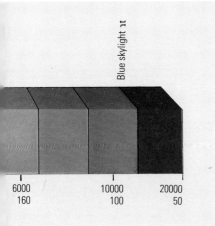

Colour conversion filters

A wide range of filters is available to raise or lower the colour temperature of light reaching the film. The table below shows which filters you can use with which films to produce a normal lighting effect. Adding filters reduces the effective film speed.

Light source	5500°K	3400°K	3200°K	2900°K	2800°K
Film type					
Daylight	No filter	80B	80A	80A+82B	80A+82C
Tungsten type A	85	No filter	82A	82C+82	82C+82A
Tungsten type B	85B	81A	No filter	82B	82C

Probably the most valuable times of the day for general colour photography are the early morning and late afternoon into evening. Low, raking sunlight is especially good for revealing the texture of a landscape, and long shadows can help to pick out subjects dramatically against dark backgrounds. The low angle also gives the biggest choice of direction: by shooting into the sun you can create silhouettes, side-lighting gives good texture and contrast of detail, while frontal lighting, with the sun directly behind the camera, can give richly saturated colours. On top of all this, the sun moves relatively quickly at these times of day, so that within the space of just one or two hours you can find a whole range of lighting conditions.

It is almost impossible to tell the difference in a photograph between sunrise and sunset, unless you know the actual scene. While sunset is usually a more comfortable time of day to work, the advantage of sunrise is that there are fewer people around – useful if you are shooting quiet landscapes. For an important picture, it is worth planning the camera viewpoint and the sun's position ahead of time; remember that the sun rises and sets at an angle, steeply in the winter, but nearly vertically in the summer.

A high sun is more difficult to work with, even though the middle of the day may well be the most convenient time for travelling and taking pictures. Portraits are rarely attractive under a midday sun – the way that the shadows fall underneath, rather than to one side, is less flattering. Flat landscapes show very few shadows, and this lack of modelling can make them look dull and uninteresting, particularly at a distance. The best subjects for a high angle of sun are often those whch already have strong shapes, strong structure or strong colours and patterns.

RIGHT The vast majority of modern film emulsions are balanced for daylight at noon (5500K). But although midday may provide the photographer with a wealth of bright and vibrant colours, strong shadows can easily mar pictures.

BELOW AND BELOW RIGHT Early morning and late afternoon into evening are the best times for general photography. The texture of a landscape can be shown to its best advantage in low, reddish sunlight (below right), while reflections of low sunlight on water can lend atmosphere to an evening shot (below).

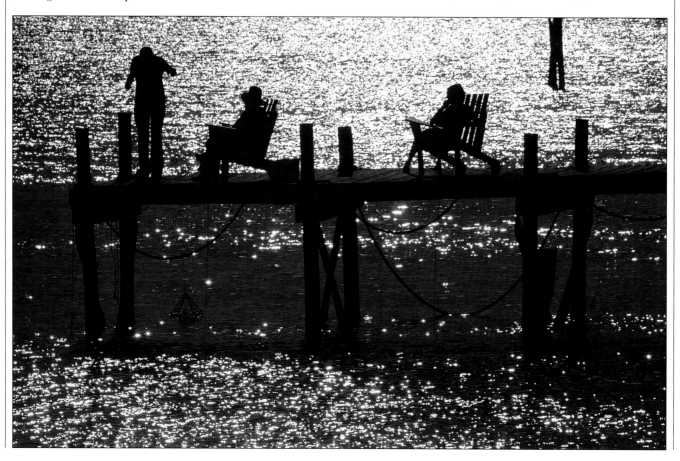

COLOUR PHOTOGRAPHY

Clear, sunny weather is only one of many natural lighting conditions. Clouds and other atmospheric conditions alter the quality of light in two ways: by reflecting sunlight and by diffusing it. There is tremendous variety even in the ways that they do this.

CLOUDS

Clouds act as reflectors in the same way that a sheet of white paper can be used in the studio to lighten shadows. The effect is very noticeable on days with fair weather cumulus – the bright, small, cotton-wool clouds. When the cloud cover is continuous, the reflection helps to kill all shadows. More important, however, is the way in which clouds diffuse the light, spreading the area from which the illumination strikes the subject. At first glance, overcast weather may seem unattractive for photography, giving a flattened, dull look to the landscape. However, this well-diffused light is very good for two things: colour saturation and detail. Because there are no bright reflections from shiny surfaces and no strong shadows, cloudy light gives good, pure colours. Green grass, for instance, actually appears lusher under clouds than in direct sunlight. Objects with complex shapes usually show up more clearly in this soft light.

BELOW Clouds, aside from being dramatic in themselves, result in light that gives good, pure colours. Also, objects with complex shapes show up more clearly in this soft light.

▮ MIST AND FOG

These conditions provide wonderful opportunities for restrained, atmospheric images. They simplify the shapes of things, give a strong sense of distance (because backgrounds recede into invisibility), and limit the tones and colours to a narrow range. The thickness of mist and fog often changes quite quickly, and can clear from an area in minutes, particularly when they have formed early in the morning and need only the warmth of the sun to burn away.

BELOW LEFT Mist and fog are of course ideal should the photographer be in search of atmospheric images. They also help to convey a sense of distance, since backgrounds tend to recede into invisibility.

BELOW A polarizing filter can increase contrast between clouds and a blue sky. Rain is a light diffuser in itself, as this picture of a tropical downpour shows.

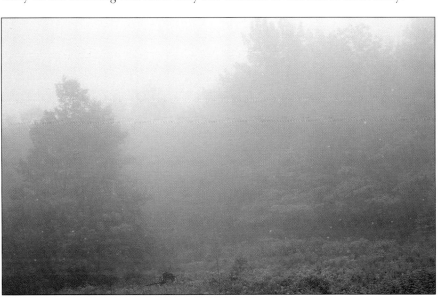

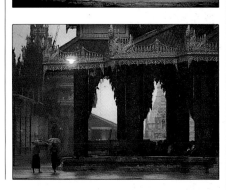

▮ HAZE

Haze also increases the sense of distance, by means of aerial perspective. It is due to the scattering of light by small particles in the atmosphere, and because the shorter, ultraviolet wavelengths are the most affected, that distant scenes in haze have a bluish tinge. Film is more sensitive than the eye to ultraviolet, so that the effects appear stronger in a photograph than they do in the real scene. This can be used to advantage as a way of keeping depth in a landscape, but to reduce the appearance of haze, use an ultraviolet filter over the lens (many photographers keep these clear glass filters fitted permanently as an additional protection for the front element of the lens).

RIGHT Overcast conditions kill shadows and allow the reproduction of detail which may be lost in direct, undiffused sunlight. The depth of this shot would be lost and the scene confused if criss-crossed by shadow.

BAD WEATHER

Rain, snow and storms usually discourage photographers but, uncomfortable though bad weather is, it offers the chance of visual drama. Being less frequently photographed than sunsets and other easier conditions, they can appear fresh and different. One of the features of bad weather is that it moves – high winds and falling rain or snow make it a very active condition – and to take advantage of it, you need to stay on your toes. Lighting conditions can change rapidly, and this means not only being prepared to alter the exposure, but also to stay alert for changes in composition and in potential pictures. Bad weather favours small cameras, and fast film. Tripods are rarely useful, as all but the heaviest will move in wind.

RAIN AND SNOW

Falling rain or snow rarely photographs as distinctly as it looks. While you can normally see individual flakes of snow and the clear streaks of raindrops, under typical lighting conditions all this is lost in a blur on the photograph. The best way of retaining the drops or flakes is to find a view in which there is a dark background and some backlighting, such as a shaft of sunlight. This kind of condition, however, is rare. Usually, it helps to include some element in the picture that indicates rain, such as a surface of water splattered with the rings from raindrops, or umbrellas. Heavy rain and snow mute colours and give a soft, impressionistic effect, similar to haze.

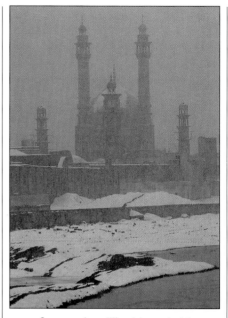

ABOVE Snow can give a diffused, impressionistic effect.

BELOW AND BELOW LEFT If the weather is the subject, then the inclusion of elements in the picture that immediately define it is a good idea. The picture below is in this sense as much about rain as the picture on the left.

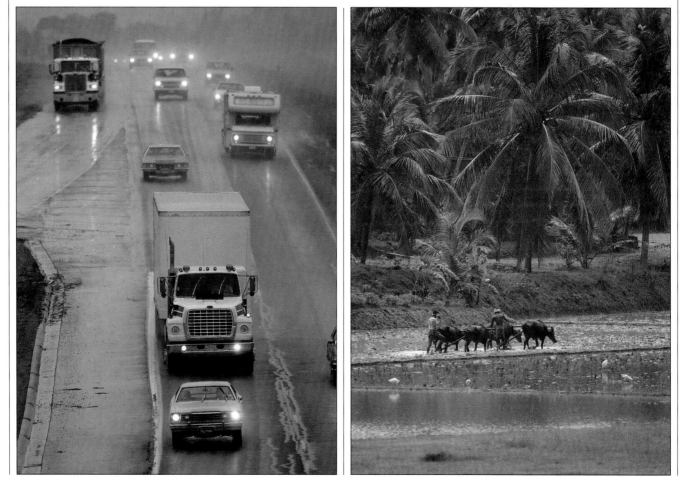

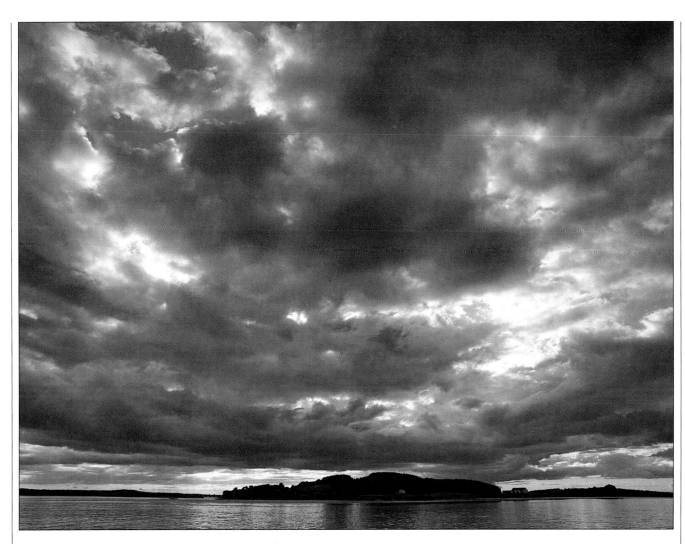

▌ STORMY SKIES

Dark, louring clouds can be the most dramatic element in a stormy landscape. Consider re-adjusting the composition to make the most of them; for instance, try placing the horizon line very low in the frame. If you have a graduated filter use this to exaggerate the darkness of the sky.

▌ LIGHTNING

In a sense, lightning takes its own picture; the flash is certainly too quick to catch by tripping the shutter. The only certain method is to anticipate where the next strike will be, place the camera on a tripod or some other secure support, open the shutter and wait. This only works when the light is so poor that you can leave the shutter open for several seconds; night-time is obviously the easiest. The actual aperture is not so critical, but with ISO 100 film, for instance, try f11 if the lightning seems close, f4 or f5,6 if distant.

▌ CAMERA CARE

Most bad weather is harmful to equipment, so keep it well covered until you shoot. In driving rain, put the camera in a plastic bag, leaving one hole for the lens and another for the viewfinder; rubber bands can secure these tightly around the camera. A friend holding an umbrella is also helpful.

ABOVE Look up, and adjust your composition to make the most of dramatic storm clouds.

BELOW The basic techniques for waterproofing a camera will also serve to keep out dust. Seal the camera in a plastic bag and secure with rubber bands. Use the open end of the bag for the lens, leave enough room inside to operate the controls and cut a small hole for the viewfinder, sealing it with another rubber band.

BRIGHT SURROUNDINGS

The sea, snow, light-coloured sand and other bright, open settings, can make a marked difference to the lighting. All of them act as reflectors, bouncing natural light back upwards, filling in shadows and generally raising the brightness level. Because they reflect the sky and sun, their appearance changes drastically with variations in the weather. The contrast, for example, can range from extremely low, on a dull, overcast day, to very high, if the sun is in front of the camera.

Without care, bright surroundings can cause difficulties with exposure. If, for instance, the camera's TTL meter reads a large area of white – a snowbank or bright surf at the seashore – the photograph will inevitably be underexposed. In a direct reading like this, the meter averages, and produces a setting that will reproduce what lies in front of it as a mid-tone. Avoiding this is largely a matter of commonsense. With a TTL meter, either point the camera to a medium-toned part of the scene in order to get an overall reading, or make a mental adjustment for the reading directly off the snow, bright sand or water.

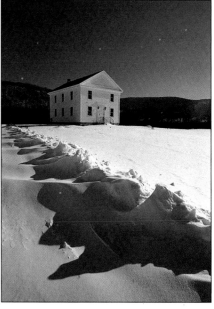

ABOVE AND LEFT Snow can easily fool a camera's TTL exposure metering system into underexposure (above). It is easy for the TTL system to suggest an exposure that could be as many as 2½ stops below the correct reading (say, 1/60sec at f11 rather than 1/60sec at f5.6 or even f4). Using a hand-held light meter can solve this problem or, alternatively, make use of the spot metering systems found in many of today's SLRs – they take a light reading from a very small area of the scene. The idea is to find the ideal brightness in a scene, and take the spot reading from there. If a shortage of suitable equipment or circumstances dictate, take an exposure reading from the most important subject in the scene.

Simply think how dark or light you would like the bright surface to appear; if sunlit snow, it will probably look best if white but not completely washed-out, still showing some texture. This level of whiteness is about 2½ stops higher than average, so open up the lens aperture by about this amount from the direct TTL reading. Normal sand would normally be less bright than this – perhaps one stop brighter than average. Mainly, this is a matter of personal judgement. If you have a handheld meter, follow its recommendations without adjustment; it measures the light, not the surfaces. Note that the general level of brightness is higher in these surroundings, often by about one stop, so do not be surprised if your camera settings are different from what you are used to in more normal landscapes.

Because reflective surroundings react to changes in the natural light, one of the great pleasures in photographing them is the variety of image, and it is shortsighted to think that there is only one optimum lighting condition. Certainly, low, raking sunlight brings out texture in sand ripples and snow, particularly if the sun is to one side or in front of the camera, but even flat lighting produces its own special visual appeal. Be careful, however, if most of the picture is in shadow under an open, clear sky because the extra brightness of the snow or sand will throw much of the blueness of the sky into the shadow area, and skin tones in particular will look strange and cold.

BELOW A hand-held light meter such as this Gossen Lunasix can be used either for incident or reflected light readings, and can be fitted with various accessory attachments.

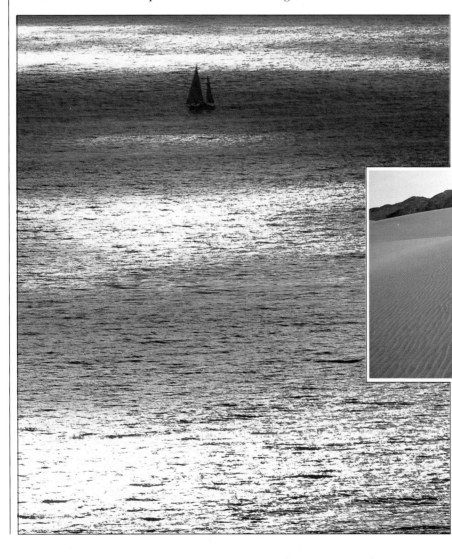

ABOVE AND LEFT Both sand and sea can make a marked difference to lighting. Sand may be one stop brighter than average, while reflected light from the sea can result in severe underexposure.

DUSK & DAWN

Some of the most interesting and dramatic lighting effects come from shooting before sunrise and after sunset. The low level of the light needs some obvious precautions – a tripod and cable release are standard equipment – but the delicate light can be a useful alternative for subjects that would otherwise be uninteresting in ordinary sunlight.

One of the most reliable ways of using twilight is to shoot against it, silhouetting subjects against the brightest area of the sky. With this technique, expose for the sky rather than the silhouetted objects in order to keep the colours rich and saturated. For safety, it is a good idea to bracket exposures (see page 77).

A variation of this silhouette approach is to photograph reflected twilight. With a slightly raised camera position, such as from a bridge, the water in a lake or river will reflect the sky, and if the weather conditions are right, this will give a broad, smooth background. Shiny, reflective subjects benefit from this treatment as well.

The lighting conditions at dusk and dawn change rapidly – far faster than you might notice at the time. Keep a careful eye on the exposure meter because the level can change within minutes. When the sun is far below the horizon, exposure times are likely to be long, running into several minutes. Reciprocity failure comes into play and introduces some uncertainty in the exposure setting, and even if you have the film manufacturer's tables for compensation (these are rarely included with the film, and usually come in a separate leaflet), bracket the exposures widely. The colour shift in a twilit landscape view may not be too serious; the colours are in any case likely to be unusual.

BELOW Keep in mind when shooting at either dusk or dawn that lighting conditions change quickly. If taking a series of shots, continually check the camera's meter: readings can change quicker than you might imagine.

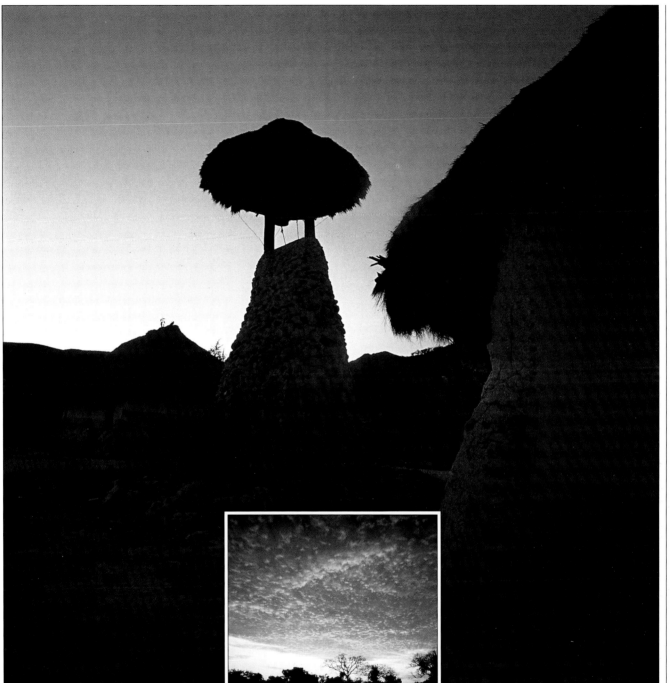

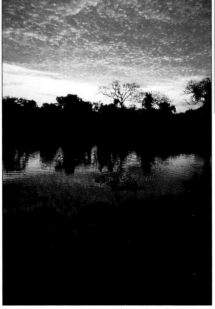

ABOVE Shooting against twilight is a reliable technique, silhouetting subjects against the brightest areas of the sky. To achieve this, expose for the sky rather than the subject and bracket exposures to be sure of a good shot.

LEFT A technique that works at either dusk or dawn is to use the reflected light on the surface of a river or lake. In this case, the photo was taken at dawn from a reasonably high viewpoint.

Electronic flash is now the most common type of photographic lighting, and the standard unit is a portable flash that will fit on the camera body and work more or less automatically. Flash bulbs are much less used now that the electronic units are reliable and fairly inexpensive.

The principle of electronic flash is an electrical discharge passed through a glass envelope (the flash tube) containing a gas such as xenon. This gives a rapid pulse of light, useless for seeing by, but ideal for exposing film. All that the camera needs to do is to synchronise the opening of the shutter with the flash discharge. Although the flash pulse from a portable unit is usually very fast indeed – around 1/50,000sec – the shutter speed on a typical SLR must be considerably slower, between 1/60sec and 1/125sec on most models, and up to 1/250sec on a few. The reason for this is that the focal plane shutter on this kind of camera works at high speeds by passing only a narrow slit across the film. The near-instantaneous flash would expose only a narrow band – just the result if you set the shutter speed incorrectly. The 'X' setting on the shutter speed dial is intended for electronic flash synchronization.

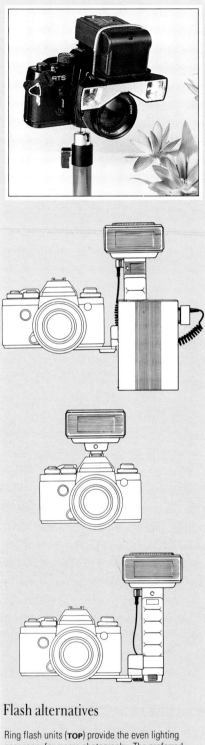

ABOVE Mounting the flashgun off the camera can eliminate the problem of red-eye.

LEFT Dedicated electronic flash has brought easy-to- use artificial lighting within the reach of every amateur.

Flash alternatives

Ring flash units (**TOP**) provide the even lighting necessary for macro photography. The preferred flashguns of many photo-journalists, hammerhead off-the-camera units (**ABOVE**) are available with re-chargeable battery packs (**SECOND FROM TOP**). Although most modern guns have a bouncehead facility, the danger of red-eye is always present with hot-shoe mounted flashguns (**THIRD FROM TOP**).

GUIDE NUMBERS and such.

GUIDE NUMBERS

The light output of a flash can be calculated in different ways, but for portable flash the usual method is a guide number. The higher the number, the more powerful the particular flash unit. The guide number is already given by the manufacturer, although, as it is usually calculated for use indoors, where the reflections from walls and ceilings add to the light, it is worth testing the recommended settings for yourself if it is not an automatic unit. Particularly if you use a flash outdoors, without any bright surroundings to help, you may find that an extra half-stop exposure is needed. Guide numbers are given either in feet or in meters; to use them, simply divide the distance to the subject into the number and the result is the aperture setting. For example, if the guide number for the film you are using is 100 (feet), and the person you are photographing is standing about 12 feet away, the setting should be f8.

DEDICATED FLASH

The easiest way of using flash is to buy a unit that is 'dedicated' to the particular make of camera. This type of flash is linked electronically to the camera's operation, and makes full automation possible, including through-the-lens automatic flash metering with some models.

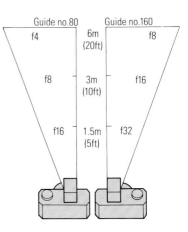

ABOVE The marked difference in power between a flash with a GN of 80 and one with a GN of 160.

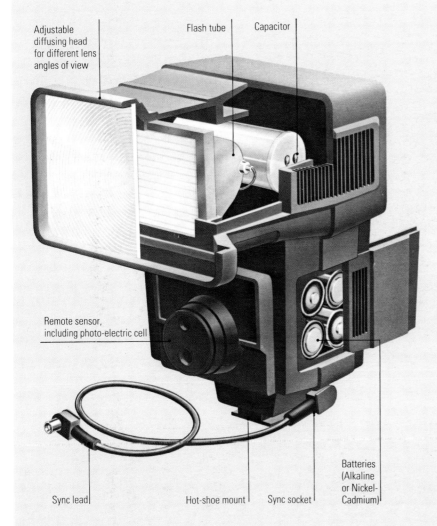

Adjustable diffusing head for different lens angles of view

Flash tube Capacitor

Remote sensor, including photo-electric cell

Sync lead Hot-shoe mount Sync socket Batteries (Alkaline or Nickel-Cadmium)

Automatic thyristor flash

In common with all electronic flash units this portable model operates by converting low voltage from the batteries into a higher voltage, and storing the charge in a capacitor. When the unit is triggered, the capacitor, with the help of a smaller trigger capacitor, discharges the stored energy in a burst, ionizing the gas in the flash tube to produce a brilliant white flash. Automatic operation is made possible by using a light-sensitive photo-cell that measures the amount of light reflected back from the subject. This is connected to a thyristor – a very fast-acting electronic switch – which can cut off the supply of energy to the flash tube at any point. Modern 'dedicated' thyristor flash guns read the flash exposure through the lens, during the exposure, but require additional contacts in the camera hot-shoe to transmit exposure information. Most dedicated flash guns come from the camera manufacturers, though an increasing number can be adapted to a variety of cameras by changing the hot-shoe connector.

For cameras without a built-in hot-shoe (for instance, some Nikon models), a detachable hot-shoe can be fitted.

The very convenience of portable flash is also its major drawback. These units are designed to be triggered from the camera position, attached to the camera body by a hot-shoe, and although this makes them easy to use and handle, it is hardly ever the best position for a main light. Being so close to the lens, there are virtually no shadows, and the result is often flat in appearance, with little in the way of modelling. An extra danger is the condition known as 'red-eye', in which light is reflected directly back from the retina of the person being photographed.

All this comes from having the flash on the camera and pointing directly forward. There are some situations which can benefit from this – notably subjects that have strong inherent colours and tones, but which are not shiny – but more often than not it is better to move the flash or modify its output in some way.

Many on-camera flash units have swivelling heads that allow the light to be aimed upwards. The idea behind this is to bounce the light off a ceiling; as most ceilings are white or lightly-coloured, the effect is to soften the illumination on the subject. At the same time, the amount of light is drastically reduced, and

A recent trend has been the appearance of SLRs with built-in flash units (such as the Ricoh XR-X, shown top), which are designed both for convenience and to overcome the problem of red-eye. Bouncehead flashguns (such as the Ricoh Speedlight 300P) are commonly available, and are generally more powerful than built-in units.

Flash Outdoors

Without the use of flash, backlit subjects (right) can be recorded as silhouettes, since the average SLR's metering system will record the bright sky as the dominant light source. Fill-in flash quite literally 'fills in' the details that have been lost in shadow.

Without fill-in flash.

you should be careful to watch for the under-exposure warning light (inside the viewfinder with a dedicated unit). In a typical domestic room, the ceiling will be about 10ft (3m) high and, if it is painted white, the loss of illumination should be in the order of about two stops. Remember, however, that for the metering to work, the sensor must be taking its reading from the subject rather than from the ceiling. So, unless the flash offers TTL metering, make sure that the sensor does not also swivel upwards.

To a limited degree, it may be possible to diffuse the flash. Some units have attachments available that act as reflectors: the flash is swivelled to aim up into a white card. For others, an over-sized head can be attached with a translucent diffusing 'window'.

BELOW Bouncing flashlight off a suitably reflective surface can give results that are devoid of the harsh shadows that are a characteristic of direct flashlight. The loss of illumination in the average domestic room with a white, 10ft-high ceiling will be in the region of two stops, and this should be taken into account when calculating exposure.

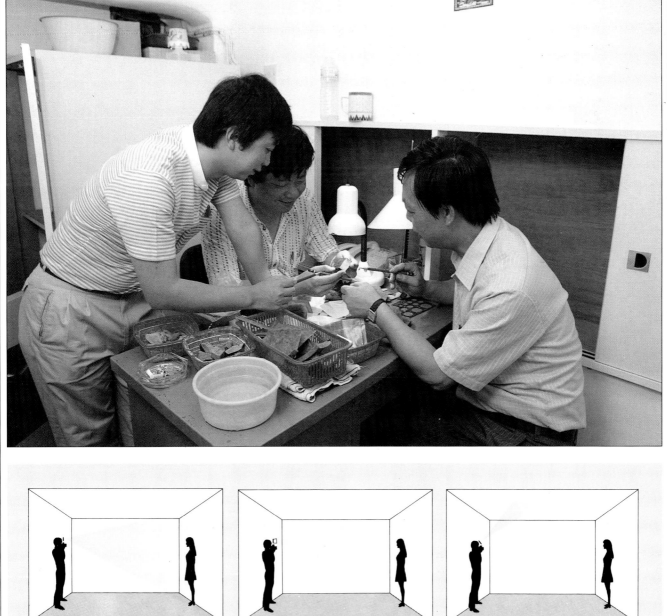

Direct flash without diffusion.

Direct flash with diffusion.

Flash bounced off ceiling.

A different use for on-camera flash is to counter the high contrast of a backlit scene by filling in the shadows. Without flash, there are just two choices when the background is bright and the subject in shadow: setting the exposure to record detail in the subject (which will leave the background overexposed and washed out), or exposing for the background (which may leave the subject almost in silhouette). If it is important to have both well-exposed, fill-in flash is the answer.

The one important precaution is to make sure that the illumination actually does fit the description and 'fills in' the foreground shadows rather than takes over entirely. There is a temptation to use too powerful a setting, but the result is distinctly artificial. As a rule of thumb, fill-in flash works best when it is not immediately obvious from the photograph that any extra lighting was used.

The simplest approach to calculating the amount of flash output is first to decide on the ratio of flash to daylight. A ratio of 1:2 is the absolute maximum; if the flash is any more powerful, the effect will be unnatural. A more useful ratio is around 1:4, which means that the flash output is four times (two stops, in other words) less than the level of the daylight. A more understated effect is possible with ratios of 1:6 and 1:8. Less than this and there is virtually no effect at all.

Apart from those flash units that deliberately allow a fill-in setting, you can adjust the flash-to-daylight balance either by altering the flash output or by altering the camera's aperture setting and shutter speed. Altering the shutter speed affects only the daylight exposure, not that of the flash, but there is an upper limit – the flash synchronization speed.

First take an exposure reading of the daylight level from the background. Set the shutter and aperture to give this. The job of the flash is now to boost the brightness of your shadowed foreground subject, so first calculate from the distance what the aperture setting should be for a full flash effect. For a 1:4 ratio, what you want is two stops less than this. So, if the reading from the background is 1/125sec at f/11 and the full flash setting for the subject works out at f/8, you would need to reduce the flash output by one further stop or make the aperture smaller by one stop. One answer here would be to shoot at 1/60sec at f16; another would be to lower the flash output, either by its output selector (if it has one) or by covering the head with a neutral density filter or a piece of white cloth with the flash unit on manual exposure.

OPPOSITE AND BELOW LEFT The trick with fill-in flash is not to make it obvious; the viewer must be fooled into thinking that you photographed the scene as you saw it. To achieve this, the temptation to use too powerful a burst of flash must be resisted. Rather, especially in scenes such as the ones shown here, a clever balance must be reached between the fore- and background lighting.

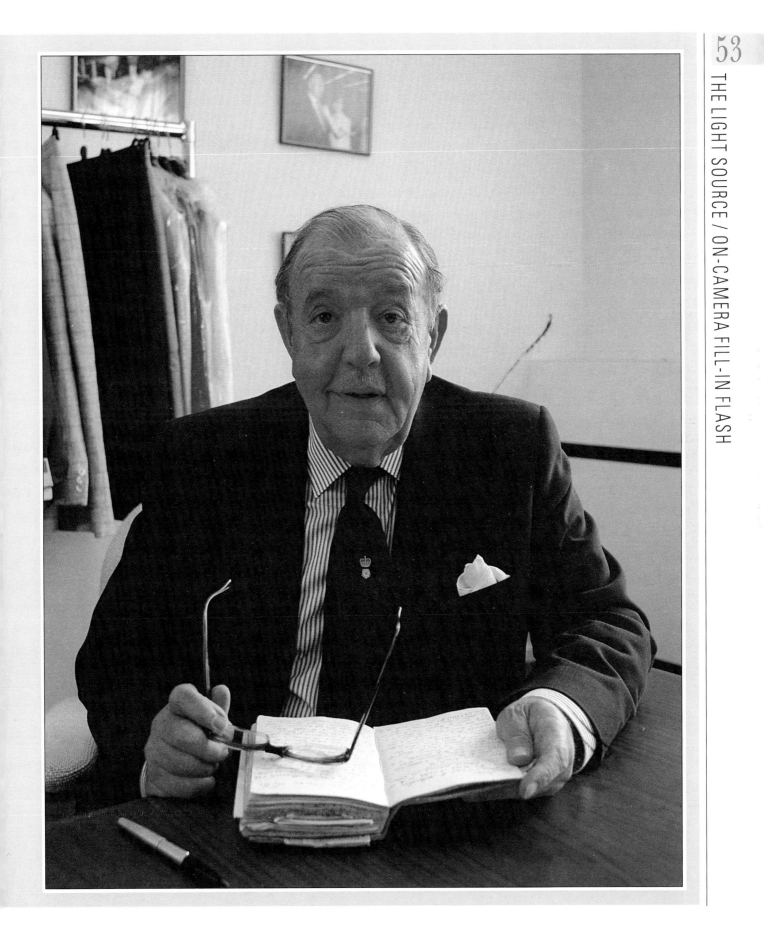

OFF-CAMERA FLASH

In any situation where you have time to work out the viewpoint and lighting, it is nearly always better to move the flash off the camera, and hold it or position it separately. This calls for a sync lead, or, in the case of a dedicated unit, an extension cable to carry connections to all the contacts. A bracket that attaches to the base of the camera can make a small improvement, but if you are taking the trouble to set up an indoor portrait, it is often worth attaching the unit to a small stand or tripod. Then, the flash can either be bounced off any large, white surface – ceiling, wall, or large white card – or be diffused by aiming it through some translucent material.

With these rather more advanced lighting techniques, a portable flash unit is by no means the only type of lighting equipment to consider. If you want to concentrate on indoor photography – portraits, for instance, or still-life shots – it is worth looking at the serious alternative: mains-powered flash. At the top end of the scale, large flash units designed for professionals are heavy and expensive, but there are many smaller units that are very convenient to use. The big advantage of a mains-powered flash is that the output can be much higher than that of a portable unit, and the recycling time can be in the order of a second or two.

BELOW Off-camera flash is preferable in situations where time is available to assess both the viewpoint and the lighting. The light may either be bounced off a reflective surface or passed through a diffusing material.

ABOVE The time taken to set up a still-life like this justifies investment in mains-powered flash.

Mains-powered units work on the same general principle as a portable flash, although on a larger scale. The flash head is usually larger, and is intended to be used with some kind of fitting: bowl reflectors or screens and boxes that diffuse the light. Because they are rarely used as direct, unmodified lighting, the idea of guide numbers is not particularly useful – the illumination depends on the type of reflector or diffuser. Instead, these units are rated in terms of their electrical output, in watt-seconds, also known as joules. There is no simple way of using this rating to work out the aperture setting, but in indoor photography, most photographers who regularly use flash regularly quickly become familiar with certain lighting set-ups, for which the exposure settings are consistent. In any case, if you go to the trouble of investing in a mains-powered flash, it is worth also buying a flash meter.

ABOVE Busy professional photographers usually find the disadvantage of mains-powered flash units – their sheer bulk – outweighed by the advantage of very fast recycling time (normally a second or two).

Basic still-life lighting

For small objects without backgrounds, a simple set that gives consistently good results can be built with a table, clamps and a smooth, flexible white surface such as formica. The white sheet propped against the wall so that it falls into a natural curve, gives an even, seamless background to the shot.

BELOW Suspending a 'window' light directly overhead suits these Victorian dolls perfectly – their heads and bodies are clearly lit against the shadowed background, while the skirts are well illuminated by reflected light from the white surface. A lower camera angle would show less white foreground, and a higher viewpoint less of the dark background.

ABOVE The subtle variations of colour in the glass of this Roman glass bowl (below) were best captured by backlighting, but for texture top-lighting was also necessary. A window light was aimed at the background, but adjusted so that a little spilled on to the bowl (above). As it was eventually to be printed as a cut-out, the edges of the glass could be defined by black card placed close-to.

LIGHTING EQUIPMENT

Always make the photographic lighting that you use do what you want, rather than accept the limitations of its design. For example, just because a flash unit comes with a small bowl reflector does not mean that it should be used always like that. Instead, think of the light as a raw material – a basic supply of illumination that must be modified to produce the required results. There are three basic things that you can do with a lighting unit: reflect it, diffuse it, or concentrate it.

▮ REFLECTION

The basic principle for softening shadows and making the illumination more even is to make the light source broader. One of the simplest ways of doing this is to bounce the light off a large, plain white surface. What happens is that, instead of the subject being lit by the direct beam of the flash, it receives its illumination from the reflector. This is the principle behind tilting a portable flash head upwards to the ceiling, but there are many other possibilities. White cards, paper or cloth hung up in appropriate positions can be reflectors, as are photographic umbrellas. The umbrellas are available in different materials: silver gives a more intense and concentrated light, while gold, for example, adds warmth.

BELOW One of the simplest ways to broaden the light source is to bounce it off a large, plain white surface. In this case, studio umbrellas are being used, although everyday objects such as white cards, cloth or even newspapers can suit the purpose.

DIFFUSION

Reflectors, although inexpensive and easy to assemble, have two disadvantages: they cannot always be suspended or positioned in exactly the right place, and they absorb a lot of light. An alternative is to shine the light through a diffuser. This can be any translucent material, such as tracing paper, thin white cloth, milky plastic, or anything similar. The most basic way of doing this is to put the light on a stand, and hang the diffusing sheet in front of it. For more control in positioning, however, the diffuser should be attached to the light. Mains-powered flash units have a fitting that allows this, but with a portable flash you may need some ingenuity.

CONCENTRATION

Although a naked lamp produces hard shadows, it is not a controlled beam. For certain kinds of shot a spotlight effect is useful, and for this the beam needs to be constricted. Lens attachments do this very well, but a cheaper alternative is to make a cylinder of black card and attach this to the front of the light. If it tapers slightly, so much the better.

Held by tension against the floor and ceiling, expanding poles (below left) are an economical use of space, although awkward to move once set up. A counter-weighted boom (below), enables a flash head or photoflood to be easily suspended over objects.

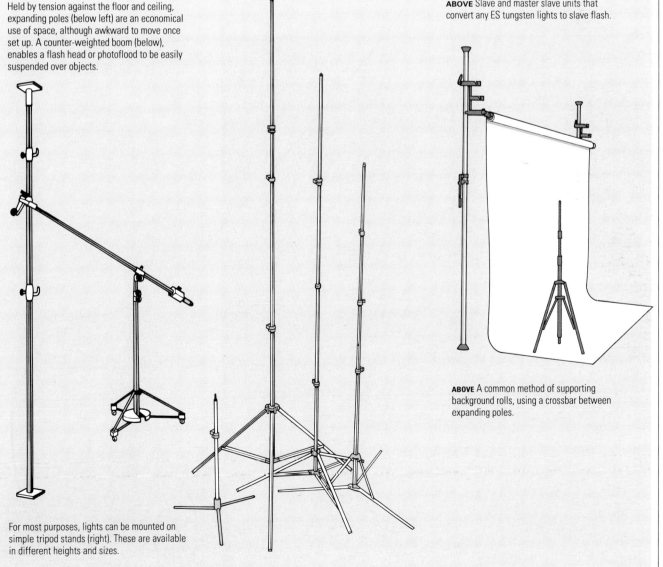

ABOVE Slave and master slave units that convert any ES tungsten lights to slave flash.

ABOVE A common method of supporting background rolls, using a crossbar between expanding poles.

For most purposes, lights can be mounted on simple tripod stands (right). These are available in different heights and sizes.

The two most common types of indoor photography that use photographic lighting (as opposed to available light) are portraits and still-life. Although there is an infinite number of ways of lighting either of these subjects, the most common methods use diffusion and reflection. Here, we use them as practical examples for the lighting equipment just described.

▋ PORTRAITS

The lighting set-up shown here (right) is probably the most reliable of any. Most portraits are taken with the idea of making the sitter look as attractive as possible, and the quality and direction of the light can help enormously. If, however, you are trying to convey, for example, the sense of character in a deeply lined face, you might consider harder lighting.

The main light is softened by using a reflecting umbrella, placed in a three-quarter position on a stand. This light gives the basic modelling. On the opposite side, a second light is used to fill in shadows, and is bounced off a larger reflecting surface so that its effect is both softer and weaker. Other optional lights are used to light up the background separately, and to highlight the hair.

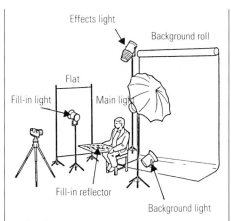

ABOVE A typical lighting set-up for a head-and-shoulders portrait; the umbrella diffuses the main light, and the fill-in light is bounced off a large white board. The effects light is fitted with a 'snoot' to concentrate the beam. The background light gives a graduated effect on a seamless roll of paper.

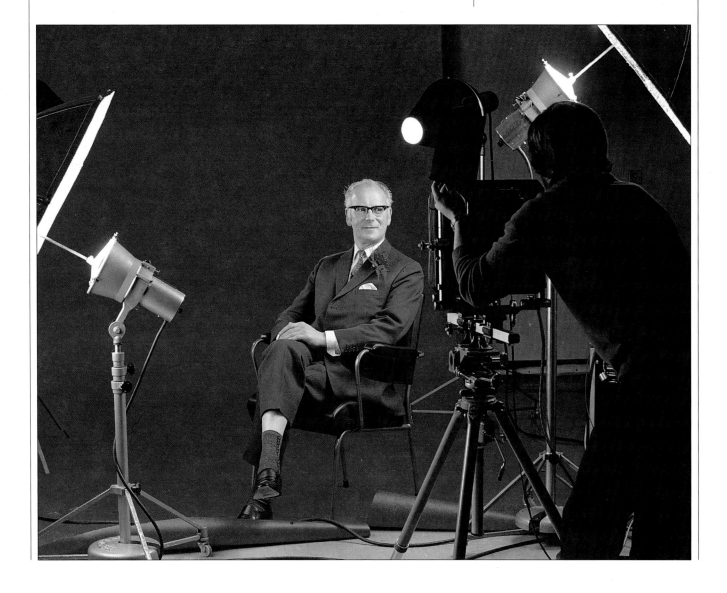

▮ STILL-LIFE

Good still-life photography depends very much on precision in the lighting – exact control to suit both the ideas of the photographer and the particular qualities of the object. Many still-life photographers use a 'window' light to give a type of diffusion that has soft but distinct shadows. These can be bought from photographic dealers, or made from wood, card or metal. Essentially, it is a kind of box, fronted with a textureless sheet of diffusing material. More often than not, the most appropriate position is over the subject, for which a boom lighting stand or a kind of 'goalpost' arrangement is useful. By varying the position of this single light, a surprising range of effects is possible. Note that, because the box-like fitting encloses the light, it can safely be used only with a flash unit, and will not work with one of the incandescent lamps described on the following pages.

ABOVE Window lights can either be bought ready-built from photographic dealers, or constructed at home from wood, card or metal. The result should resemble a kind of box, fronted with a sheet of diffusing material.

The diffused illumination from a 'window' light should give soft but distinct shadows (above). The softer light is ideal for still life work when reflective subjects are involved (above left). A common technique is to use the 'window' light to backlight a still life set (left).

TUNGSTEN LIGHTING

Incandescent lamps, or 'hot' lights as they are sometimes called, have for long been the mainstay of photographic lighting. Even though they have now been largely superseded by flash in most situations, they remain irreplaceable for certain types of photograph.

All lamps that work by burning a filament are incandescent. The most familiar are domestic tungsten lamps, but those designed for photographic use burn more brightly. Some of the more intense ones use a quartz-like envelope instead of regular glass, and use halogen gas to prevent darkening with age and use. The colour temperature is usually 3200K, but sometimes 3400K. They are normally used with Type B film, although using a blue acetate sheet in front of the lamp can convert the light to the colour of daylight.

The output is measured in terms of the power drawn. The weakest operate at about 275 watts, but wattages of up to 1000 are common. The brighter the lamp, the hotter it is in use, and this kind of lighting needs care. In particular, it is dangerous to surround and enclose a lamp in some of the ways that flash units allow. Voltage fluctuations cause differences in the colour temperature, and a drop of 10% is likely to lower the colour temperature by about 100K. The more sophisticated studio lamps have adjustable flaps close to the front of the unit; known as 'barn doors', they can be used to prevent light spilling out in unwanted directions.

ABOVE Tungsten lighting remains irreplaceable for certain types of shot. Here, it has enabled the photographer to predict exactly how the scene will look, and added a 'vintage' appearance to the set.

BELOW Tungsten is still without parallel when shooting room sets. Note the tungsten light sources in this scene include the household lights in the background.

Unlike flash, tungsten lighting is continuous, and one of the things that makes it so easy to work with is that you can see exactly what lighting effect will be caught on film (with portable flash you must either guess or rely on experience). They can be added to existing lighting, and the overall lighting set-up can be tuned by eye alone. For shooting room interiors, particularly large areas, they are without equal. Even if the depth of field must be good, and a slow film is being used, adjusting the exposure is simply a matter of leaving the shutter open longer; the alternative with flash is to fire it repeatedly, but the recycling time needed between each discharge can make this process even longer than a continuous-light exposure.

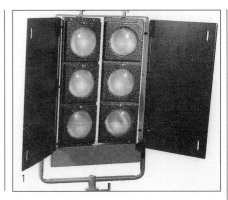

1

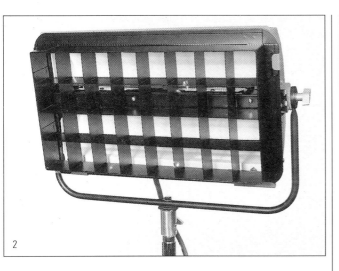

2

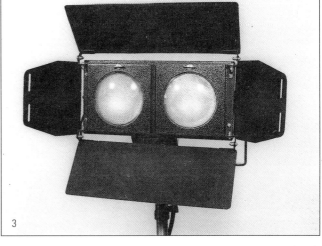

3

Tungsten Lights

Lights are available with 'barn doors' (1 and 3), adjustable flaps that prevent light from falling in unwanted directions. 'Egg crates' (2) make for a more directional tungsten light. Tungsten lights are available with a bar to conceal the lamp (4).

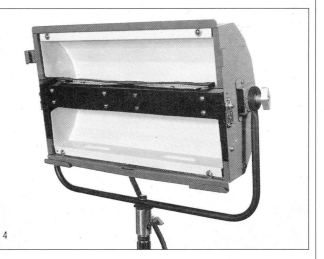

4

RIGHT Softlight with bar (right), totalight (centre right) and photoflood (far right).

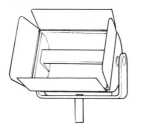

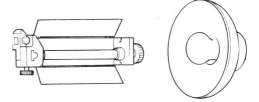

Tungsten lamps are still the standard type of lighting in most domestic interiors, even though fluorescent strip lights are steadily replacing them in larger public areas and offices. Many restaurants also keep tungsten in preference to fluorescent because of the warmer, more friendly atmosphere it creates. The colour temperature depends very much on the wattage of the lamps, and this is usually less than 2900K. So, even on Type B film, domestic tungsten lighting appears yellowish or orange.

To compensate for this warm cast, you would need a bluish filter in Kodak's 80 series when using Type B film. Either an 80C or 80D filter will give a reasonably neutral result, but with daylight-balanced film you would have to add an 80B on top of this. However, this kind of precision is not necessary; psychologically, a warm cast to a room is seen by most people to be quite attractive. If you are shooting colour negative film, a considerable degree of correction is possible at the printing stage anyway.

What is usually more of a problem is the way that tungsten lamps tend to be positioned and used in interiors. More often than not, they are exposed to view rather than concealed (as most strip lights are used). This makes for high contrast, with pools of light, and there is often no way to avoid a bright lamp appearing in shot. The best answer is to choose a viewpoint and composition that either hides a lamp from direct view behind some other object (such as a pillar or piece of furniture) or keeps it small in the frame.

Light levels from domestic tungsten lamps are low, and call for either a slow-to-medium film on a tripod, or a fast film if you want to shoot at speeds that will freeze normal movement and allow you to hold the camera by hand. For example, an average home interior with ISO 64 film would need a setting in the region of ¼sec at f/2.8; with ISO 320 film this could be 1/30sec at f/2 – just acceptable for a handheld shot. Remember that, if you are using a fast daylight-balanced film, adding a blue filter such as an 80B will cost some exposure – about 1⅔ stops. To increase the possible shutter speed, uprate the film; ISO 160 Ektachrome, for example, can be used at ISO 320 if you push-process it by an extra stop.

RIGHT Tungsten lighting is still the standard illumination for many interiors, and is invariably exposed to view rather than hidden. In this case, the presence of the candelabras has been exploited as a positive advantage.

BELOW The orange cast resulting from the use of daylight film to record tungsten-lit scenes need not always be unpleasant. As in this example, that orange hue can be used to add warmth to a candid shot.

ABOVE Light levels from domestic tungsten lamps tend to be low, so it is advisable to use a faster film if camera shake is to be avoided.

COLOUR PHOTOGRAPHY

The most common type of artificial lighting, both outdoors and indoors, is now fluorescent. The major problem for the photographer is that these strip lights do not reproduce on film the way they appear to the eye. The reason for this lies in the way they work. Inside the glass envelope, an electrical discharge causes the gas to glow, and a fluorescent coating to the glass helps to make this look white. However, the spectrum of light that it emits has gaps, particularly in the red end of the spectrum. The result is that, while the effect is visually close to white, on film it looks green.

This would not be so bad if all fluorescent lamps were consistently green. However, there are different types, a variety of brands, and they change colour with age. The only two ways of making sure of exact correction are to use a colour meter or to make a test with several filters. For most people, neither of these alternatives is really acceptable, so the standard solution is to use one basic filter and hope for the best. All major filter manufacturers supply a fluorescent-correction filter, which is close to magenta with a strength equivalent to about CC30 on the Kodak Wratten scale. In fact, with a set of three gelatin Colour Compensating filters – CC10M, CC20M, and CC30M – you can bracket exposures and be reasonably certain of a close match. As fluorescent lights are deficient in red, daylight-balanced film is a better choice than Type B, which needs stronger filtration and so longer exposures.

For off-the-cuff shooting, a magenta filter over the lens is as much preparation as you can make. If, however, you have more time to set up a shot, there are alternatives. One is to wrap magenta acetate sheets around the strip lights (these are available from photographic dealers and suppliers of theatrical lighting). Another is to aim a tungsten photographic lamp directly up into the ceiling where the fluorescent lamps are – the addition of orange light will help to overcome the green cast. A third possibility is to use portable flash –if you fit a magenta correction filter over the lens, and a CC30 green filter over the flash head, everything should balance.

BELOW A typical example of the sickly green cast that results from shooting with daylight-balanced film under fluorescent lights. Unfortunately, the lights are not consistently green, but vary according to make and age.

ABOVE Multi-coloured neon displays do not present the same problems as fluorescents, and can give rewarding results.

LEFT Photographers wishing to use daylight-balanced film under tungsten lighting can avoid the green cast with the use of a simple filter, as shown here. Major filter manufacturers can supply a fluorescent-correction filter, which has a strength close to CC30 on the Kodak Wratten scale.

VAPOUR LAMPS

Vapour discharge lighting, used almost exclusively in large outdoor areas such as streets, stadiums and factory complexes, works on a similar principle to fluorescent lighting, but the lamps are uncoated. There are three main types: sodium vapour, mercury vapour and multi-vapour. Only the last of these is in any way easy to work with, so the trick is being able to identify which is which.

Sodium vapour is very distinctive by its yellow cast, which starts as red when the lamps are first switched on. It is popular for street lighting and for flood-lighting major public buildings. The spectrum of sodium vapour light is the narrowest of all – about 95% of the light is in the yellow-green part of the spectrum and there is no filtration that you can use to make it look natural. Filters can only work with the lighting that exists, and there is just no red or blue in this kind of lamp.

Mercury vapour and multi-vapour lamps are difficult to distinguish just by looking at them. Both look more or less white, but while multi-vapour photographs quite naturally, mercury vapour is in fact quite strongly blue. The clue is in where they are used. In a sports stadium, you can be fairly certain that the lamps are multi-vapour because matches are televised and the lighting has to be balanced. Elsewhere, assume it is mercury vapour. Use no filters for multi-vapour, but try a CC30 red or CC40 red with mercury lamps.

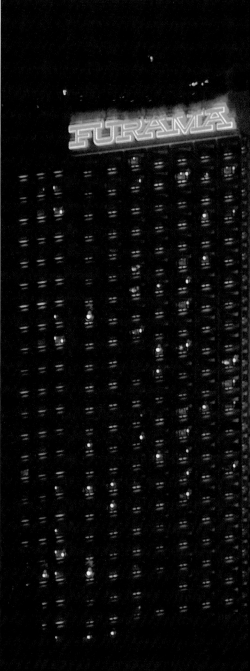

Universal holder Gelatin holder Lens shade

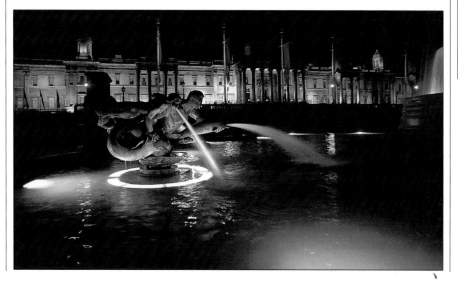

ABOVE LEFT Filter holders are attached to the lens via an adapter ring. (The gelatin holder is used to hold thin acrylic sheets which actually act as masks rather than filters for special effects shots.) A lens shade helps reduce undesirable flare and surface reflection.

Sodium vapour is very popular for street lighting and for floodlighting public buildings. However, it is impossible to filter out the yellow-green cast in photographs.

ABOVE The cast caused by mercury vapour lighting need not be unappealing, but if the photographer wishes to filter the cast out, either a CC30 red or CC40 red filter may be used.

FLAMES & FIREWORKS

Flames, in their various forms, from candles and bonfires to fireworks, are a special case of available light. While they usually offer very poor levels of illumination, they are themselves a fascinating visual subject. Photographing by their light normally requires taking them into account as important parts of the composition. Nevertheless, the criteria for calculating the exposure vary. If you are photographing by the light of a flame that is out of shot, the exposure will have to be much greater than if the flames themselves are the subject.

In the first case, take a direct reading, with the TTL meter, from an area of the picture away from the light source. Better still, use a handheld incident meter. If the flames are the subject, a direct reading from them will give a good, rich colour, although the surroundings may be under-exposed. One effective type of composition using flames is to position yourself so that one or more subjects are silhouetted against them. Daylight-balanced film will give a more intense red/orange colour than does the tungsten-balanced type. Because flames are not seen by most people as a normal light source, there is no point at all in attempting to colour-correct the scene by using filters. You will normally need a fast film for handheld photography, but if the circumstances allow a tripod (if, for example, there are no people moving about in the picture), a slower film with a finer grain will give a better image quality.

Fireworks are a form of flames, and easy to photograph very successfully if you take certain precautions. The chief thing to remember is that the shower of a bursting firework can only be captured with a time exposure. The shorter the exposure, the smaller and less impressive it will appear. The easiest way of setting up a firework shot is to choose a lens that encompasses the entire scene – the setting (which may include buildings in the case of a major firework display) and the entire height reached by the rockets. Watching a few go off first will help you establish your bearings. Then, you can lock the camera in position on a tripod, and wait. As you see the rocket rise, open the shutter, and leave it open until the last remnants of the burst have died away. You can even leave the shutter open to record several overlapping bursts. The aperture setting is rarely critical: with ISO 100 film, within a stop or so of f/4 will be fine.

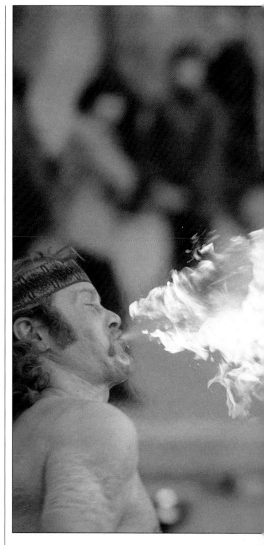

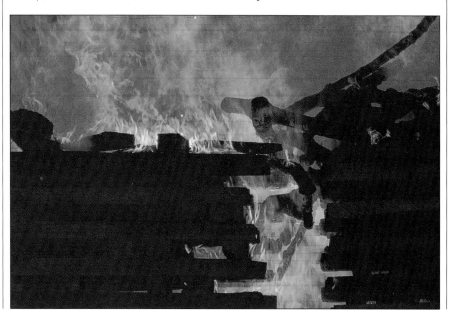

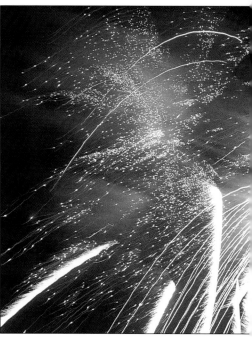

LEFT The opportunity to make flames the centre of the composition should not be missed at shows and fairs.

BELOW A balance must be achieved between the exposure for the flame and its surroundings; in this instance, flash has been used to make that compromise.

BELOW LEFT As a general rule, longer exposures result in more impressive photographs of fireworks.

BELOW, FAR LEFT Silhouetting objects against flames by exposing for the brightest light can make for dramatic images.

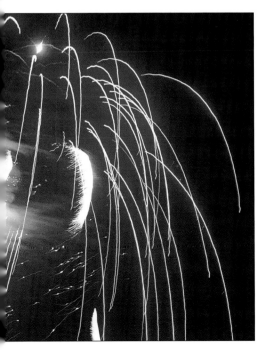

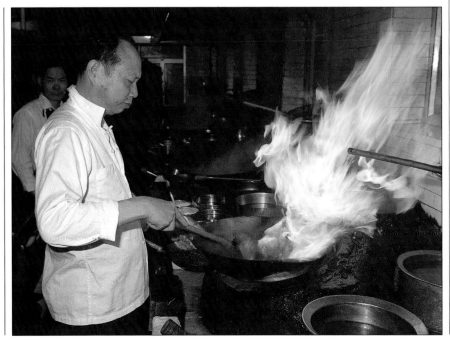

Filters that fit over the lens are a key method of controlling the colour and tone of your images. The important filters are not, however, the special effects and trick filters that produce rainbows, stars and drastic colour changes. Although these can sometimes be fun to experiment with, the filters for serious use are those that balance the light, compensate for shifts, cut parts of the spectrum and alter contrast. Few photographers maintain a full set, but it is as well to know which filter will do what.

▮ LIGHT BALANCING FILTERS

This range of filters is used to match the film to the light. We have already seen why this is necessary in selecting daylight or tungsten-balanced film. However, you may often find yourself with the wrong film for the light source; for instance, if you have been using regular daylight film but suddenly find an opportunity for an indoor picture. In this case, there is a blue filter to balance the light – 80A in the Kodak series (there are equivalent filters from other manufacturers, with different designations). The opposite filter, for using Type B film in daylight, is an 85B. These two filters are the strongest that are normally used, but a whole range of weaker filters is available for making slight corrections. One of the commonest uses is on an overcast day, when the overall colour balance is a little cool. To warm up the image, many photographers use an 81, 81A or 81C filter. These are straw-coloured and give just a hint of warmth. Indoors, using available domestic tungsten lighting, cooling correction may be needed, as the colour temperature of these lamps is lower than the 3200K of type B film.

▮ COLOUR COMPENSATION FILTERS

These filters are for correcting colour shifts – the kind that may be due to differences in film manufacture, reciprocity failure or to some artificial light sources such as fluorescent and vapour lamps. They are available in six basic colours: red, blue, green, cyan, yellow and magenta. There are different strengths for each, and in the right combination, any colour can be created.

A polarizing filter was used for the shot above, which cut out the reflection from the surface of the water; but the effect is unsatisfactory because of the lack of light altogether. The shot without the filter (top) is probably better. Filters will not solve every problem.

BELOW AND BELOW LEFT Ultra violet light can make distant haze appear bluish. A UV filter can correct this.

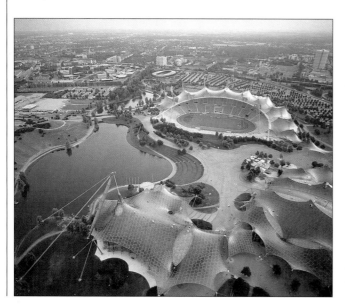

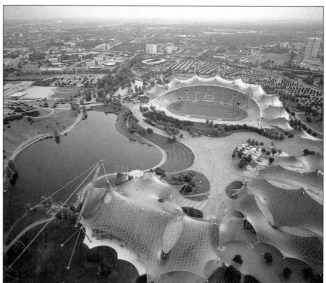

■ ULTRAVIOLET FILTERS

These plain, or slightly yellowish, filters are designed to cut the response of film to invisible UV wavelengths. These wavelengths make distant haze appear bluish and add a blue cast to pictures taken on mountains. Improvements in recent years in film has made UV filters less dramatic in their effect on colour film, but still useful (they also protect the front of the lens).

■ POLARIZING FILTERS

Daylight is partly polarized, which means that it vibrates in only one plane. Although this effect is normally invisible, it can be used by means of a polarizing filter, which allows light through in just one plane. If the plane of the daylight and that of the filter are lined up, there is no effect, but if the filter is rotated, it quenches the polarized light. In practice, this affects reflections from anything except metal, and the most obvious effects are when photographing water or glass. If the camera view is at about 35 degrees, the surface reflections will virtually disappear. And, as the blue of a clear sky is caused by light being reflected off minute particles in the atmosphere, the blue is intensified by the filter. This sky-darkening is strongest at right angles to the sun, and weakest in

ABOVE Since the blue of a clear sky is caused by light being reflected off tiny particles in the atmosphere, that blue can be deepened with the use of a polarizing filter.

How Filters Work

These diagrams (below) show how coloured filters subtract from basic white light. The three filters are of the complementary colours, yellow, magenta and cyan. The yellow filter blocks the path of blue light rays, allowing red and green to pass unhindered. In the same way the magenta filter blocks green light rays, and the cyan filter blocks red. When all three filters are combined together no light at all is allowed through, and the result is black.

The two sets of circles (right) show the two ways of creating colours photographically. The three primary colours – blue, red and green – when mixed equally, create white. In combinations of two they create complementary colours – blue and red make magenta, green and red make yellow, and blue and green make cyan. This is the additive process. In the subtractive process, complementary colours subtract from white light to produce the primary colours and black.

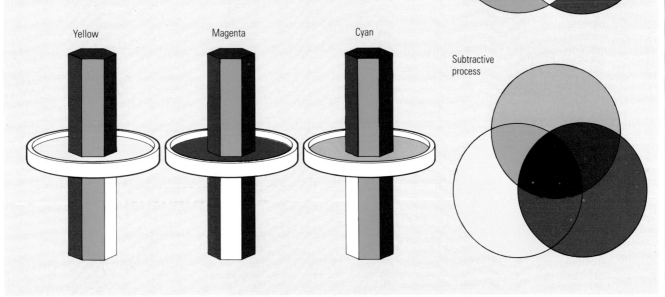

the direction of the sun, directly away from it, and close to the horizon. An especially useful application of polarizing filters is in cutting haze in a distant view; they are much more effective than a UV filter. Polarizing filters absorb quite a lot of light, and the price to pay for using one is that you will need to adjust the exposure by about 1⅓ stops. A TTL meter automatically makes this compensation.

▮ NEUTRAL DENSITY FILTERS
These are plain grey filters, in different strengths, and simply reduce the over-all exposure to the film. As it is usually possible to do just this by closing down the aperture or shortening the shutter speed, they are not often needed, but can be useful if you have a very fast film on a bright day, or want to limit the depth of field to a narrow zone. Alternatively, you might want to introduce motion blur with a long shutter speed.

▮ GRADUATED FILTERS
These very useful filters are toned over a part of the area, with the remainder clear. The division between the dark and clear halves is shaded gradually, so that in use there is no obvious line between the two.

▮ DIFFUSING FILTERS
The glass in these filters is usually either mottled or etched in some way to break up the definition of the image slightly. The exact effect varies between makes, but in general they conceal detail (which may be useful in a portrait, to hide skin blemishes), and create a halo around subjects in backlit shots.

▮ FOG FILTERS
Superficially similar to diffusing filters, these cut both colour saturation and contrast, in much the same way as real fog and mist. Some fog filters are graduated as well, so that just the upper half of the filter is affected; this can, with the right view, give a more natural treatment, with the fog appearing to increase with distance.

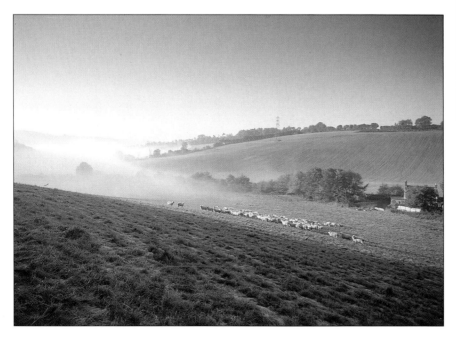

TOP A graduated filter was used here to tone down the sky so that the buildings were not drowned by excessive contrast.

ABOVE The mottled glass of a diffusing filter is particularly effective in portraiture.

LEFT The atmospheric effect of the mist was enhanced with the aid of a graduated fog filter.

Fog Filters

With filter A

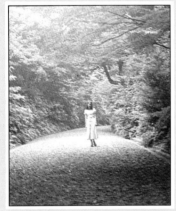

With filter B

Fog filters can be of different strengths; the top picture, using filter A, is less affected than the one below, using filter B. They can be combined to produce an effect similar to dense fog. The effect can be varied by changing the aperture of the lens, but stepping down too far will tend to cancel out the filter.

A

B

Neutral Density Filters

With ND × 2

With ND × 4

With ND × 8

Neutral density filters are used to limit the amount of light entering the camera lens for three reasons: to adjust for the film speed (if, for example, you are using a very fast film on a bright day); to lower the shutter speed for special effects; and to decrease the depth of field.

ND × 2

ND × 4

ND × 8

Diffusing Filters

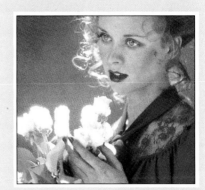

Standard

With Duto

Standard diffusing filters give an overall soft-focus effect because of their uneven surfaces. With the 'Duto' diffusing filter from Hoya, which has fine concentric lines etched onto it, the centre of the image remains sharp.

CHOOSING THE EXPOSURE

Getting the exposure right is probably one of the main concerns in photography, even though most modern 35mm SLRs are fully automated to deal with it. What makes an exposure 'right' is actually a mixture of how you saw the original scene and the technical needs of the film. An essential first step in being able to control exposure is to understand the principles rather than to rely blindly on the camera's built-in meter. Automatic metering works wonderfully most of the time, but when the lighting conditions are too unusual for it you should be able to take over yourself. To begin, there are three ways of measuring exposure, only one of which is used by a built-in camera meter:

■ REFLECTED LIGHT READINGS

These are readings of the amount of light reflected towards the camera from the subject. Under the same lighting, a dark surface reflects less light than a bright one. TTL camera metering works in this way, as does a handheld meter pointed towards the subject. For average-toned scenes (and most are, by definition), this type of reading works perfectly well. Difficulties arise when the subject is very dark, very light, backlit reflected readings tend to give settings that make blacks too light or whites too dark.

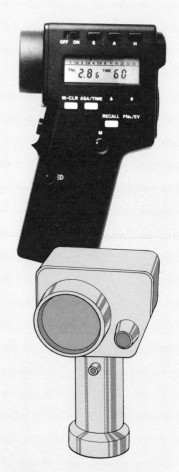

ABOVE Hand-held spot meters take accurate reflected light readings, and can be aimed optically at subjects.

Methods of using a hand-held meter include: (1) pointing the meter directly towards the subject to measure the light; (2) taking readings from the brightest and darkest areas of a subject and making a compromise between them; (3) aiming the meter at an 18% grey card, which has average reflectance, as a substitute for the subject; (4) using the meter to take an incident light reading of the light falling directly onto the subject.

ABOVE Exactly the sort of high-contrast scene that could fool a camera's built-in light meter. Here, it might be wise to use a hand-held meter to take readings from the brightest and darkest areas of the subject, then calculate a compromise between them.

■ INCIDENT LIGHT READINGS

The shortcomings of reflected readings are caused by differences in the subject, so that in theory, the most consistent readings should be of the light alone. Incident readings do just this, but need a handheld meter fitted with a cone or dome of translucent plastic over the sensor. This dome is held in the same position as the subject, facing toward the camera. In effect, the meter with its dome acts as an average subject. Because incident readings are not influenced by the subject or the background, they are ideal for tricky lighting situations. Most professionals carry one, and they are the normal method of measuring exposure in studio photography.

■ SUBSTITUTE READINGS

Reflected light readings that are not influenced by the brightness of the subject are possible, by substituting some other surface. The most accurate is a card that is toned a completely average grey. It reflects exactly 18% of the light falling on it. Such 18% grey cards can be bought at photographic stores. Two alternatives are white card readings (from any completely white but not-too-shiny surface) to which is added 2½ or 3 stops, and readings from your hand. This latter method depends on your knowing the difference in brightness between your skin and average grey.

BELOW RIGHT Scenes with a relatively limited contrast range can usually be handled perfectly adequately by the average camera's built-in light meter.

BELOW LEFT Reflected light readings are ideal in situations such as this, where the contrast varies from very dark to very bright. The readings are taken of the amount of light falling on the camera from the subject.

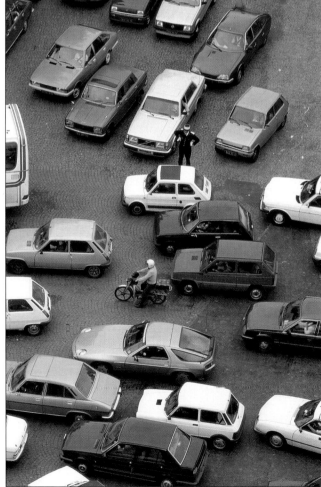

CHOOSING THE EXPOSURE

How much you can rely on the TTL metering system in your camera depends on its sophistication. Currently, the most advanced technique is multi-pattern metering, in which the picture area measured by the camera's meter, is divided into segments. Each of these segments is metered individually, and the pattern is then compared with similar patterns already programmed into the electronic memory. Certain patterns usually indicate types of lighting condition (a dark centre and bright surround is typical of backlighting), and the exposure circuits react accordingly. Nevertheless, the foolproof method of getting the exposure you want is to know yourself more or less what it should be. To do this, practice taking readings, either with the camera's meter set to manual, or with a hand-held meter as a back-up.

▉ AVERAGE READINGS

This is the standard method – an overall reading that averages everything in the shot. It usually works. One precaution in a scene with a bright sky is to meter the view below the skyline. Most TTL meters are biased for this anyway, but with a handheld meter, shade the top with your hand.

▉ KEY READINGS

With this technique, you choose in advance the most important tone in the scene, measure that, and set the exposure to suit. Several cameras with TTL metering have this option, using a small central area (or spot) of the viewfinder. Otherwise, the classic method is with a spot meter, which measures over a one degree angle of view. Doing this, you can ignore a strongly contrasting background.

BELOW LEFT The best approach to low-contrast scenes such as this is to take an average reading. Since the vast majority of TTL meters built to cameras do this anyway, the risk of the exposure going astray for this type of shot is minimized. If a hand-held meter is to be used, shade the top with your hand (above) so that the reading is not overly influenced by the sky.

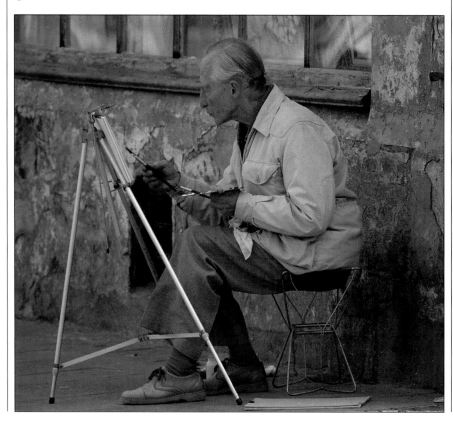

ABOVE The safest technique in this instance would be to take range readings. Take readings using an incident meter from the darkest and brightest areas, excluding reflections and deep blacks. Then, if the range between the two is no higher than seven stops for negatives and five stops for slides, calculate an average of the two.

BELOW Night shots are notorious for providing exposure difficulties. Here, it is advisable to bracket exposures, starting with a reading from the most important subjects and then bracketing, for example, two stops in either direction.

▌ RANGE READINGS

These are a kind of 'thinking version' of average readings. The technique is to measure the brightest and darkest parts of a scene, excluding reflections and deep black. With an incident meter, measure the brightest lighting and the darkest shadow. Provided that the range between the two is no higher than seven stops for negative and five stops for slide film, the average of the two readings should give a reasonable exposure.

▌ BRACKETING

Most professionals bracket exposures around what they judge to be the right setting. This involves taking a rapid sequence, changing the exposure between each by half a stop.

f numbers	Shutter speeds (sec.)										
	1	1/2	1/4	1/8	1/15	1/30	1/60	1/125	1/250	1/500	1/1000
1	0	1	2	3	4	5	6	7	8	9	10
1.4	1	2	3	4	5	6	7	8	9	10	11
2	2	3	4	5	6	7	8	9	10	11	12
2.8	3	4	5	6	7	8	9	10	11	12	13
4	4	5	6	7	8	9	10	11	12	13	14
5.6	5	6	7	8	9	10	11	12	13	14	15
8	6	7	8	9	10	11	12	13	14	15	16
11	7	8	9	10	11	12	13	14	15	16	17
16	8	9	10	11	12	13	14	15	16	17	18
22	9	10	11	12	13	14	15	16	17	18	19
32	10	11	12	13	14	15	16	17	18	19	20

COLOUR PHOTOGRAPHY

Close-up images have a special appeal in photography, because they open up a fresh visual area. The relative ease with which a camera can be used to probe small scales brings a world of patterns and scenes that we do not normally see. The small scale makes it possible to control the lighting exactly, whether using natural lighting, flash or photographic lamps. There are, however, some special problems and precautions.

Close-up photography begins at the point below which a normal lens cannot focus. This is normally just a few feet, and the greatest reproduction ratio (the ratio of the image to the subject size) is about 1:7. To close in more needs either a supplementary magnifying lens attached to the camera lens, or some means of moving the camera lens forward from the body and away from the film plane. The choice of close-up equipment reflects this: there are supplementary close-up lenses for modest magnifications, macro lenses that have especially long focusing mechanisms, extension rings and extension bellows.

Extending the lens from the film is the basic way of getting a magnified image, but it also reduces the amount of light that reaches the film. So, the greater the magnification, the more compensation is needed, either by opening the lens aperture or by increasing the exposure time. Alternatively, increasing the strength of the light or bringing it closer will make up the difference.

In practice, the difficulty of working out this compensation depends on the kind of camera you use, and on the type of lighting. If you measure the light reaching the film, as does a TTL meter, the exposure settings will be accurate. Otherwise, some calculation is needed (see box). With flash, if you have a dedicated unit and the reading is made off the film plane, rather than from an epso, there are no problems. Otherwise, position the flash according to the formula given in the box.

ABOVE Normal lenses do not have the close-focus capability required for true macro photography. However, shots such as this are quite possible with normal lenses if extension rings or extension bellows are added.

Macro lens

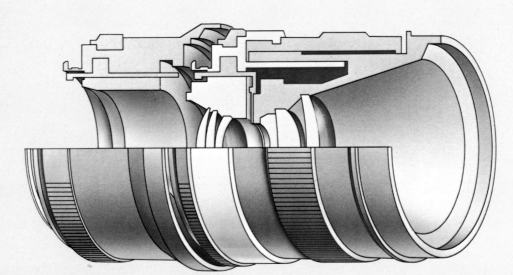

This 60mm macro lens has an angle of view of 39° and a wide focusing range from infinity down to 27cm, giving a maximum reproduction scale of 1:2. By adding the accompanying extension ring, the reproduction scale can be increased to 1:1. In addition, the maximum aperture of f2.8 is wide enough for most general applications.

Allowing for the Lens Extension

The following formula gives the increase in exposure. Translate this into f-stops by means of the table below.

$$\text{Exposure increase} = \frac{(\text{Lens focal length} + \text{Extension}) \times 2}{\text{Lens focal length}}$$

Alternatively, if you use flash, position it according to this formula:

$$\text{Flash-to subject distance} = \frac{\text{Flash guide number}}{\text{Aperture} \times (\text{Magnification} + 1)}$$

Exposure increase and f-stops

EXPOSURE INCREASE	INCREASE IN F-STOPS
1.2	1/3
1.4	1/2
1.7	2/3
2	1
2.3	1 1/3
2.6	1 1/3
2.9	1 1/2
3.2	1 1/2
3.6	1 2/3
4	2

RIGHT The real attraction of close-up photography is the way it can open up a whole new world; objects or aspects of objects that may otherwise have been ignored take on a new light.

BELOW In general, hot-shoe mounted flashguns are not suited to close-up work. Ring-flash units, which can be attached to the front of your camera's light, provide the even lighting necessary.

MAKING COLOUR THE SUBJECT

There is an important difference between true colour photography and merely photographing with colour film. You can treat colour as no more than another quality that enters the frame, whether it is wanted or not; or you can consciously look for the relationships between colours, altering your viewpoint, composition, and even selecting what you photograph on the basis of colour values.

Many photographers who grew up working in black-and-white adapted to colour film by treating it only as a way of colouring the kind of picture that they had always been shooting. At the other extreme, some photographers are attracted by the sensuousness of colour, treating it as something almost tangible. Pete Turner is one of the best known modern photographers who uses this approach.

While both methods are perfectly acceptable, we will concentrate in this section of the book on developing colour awareness. More than most other visual qualities, colour needs a trained eye if it is to be caught and used in a photograph. The reason for this lies in our easy acceptance of colours. Almost too easily, we often respond to colours around us subjectively, without really thinking about them. This is fine for enjoyment of colour, but in order to select it and compose with it in a camera's viewfinder, it is important to know how different colours interact, which hues are common and uncommon, and so on. As with music, concentrating on colour enables you to be much more sensitive to it and more discriminating.

ABOVE A good colour photographer must be continually aware of unusual or attractive combinations. Here, green, red and blue combine powerfully, making the eye dance from the bright lower part of the picture to the upper darkness.

LEFT A major problem encountered by photographers when beginning colour work is ignorance caused by over-familiarity; because we encounter certain colours every day of our lives, we tend to ignore their photographic potential. Here, a simple, strong yellow has been used to completely dominate the scene, creating a very striking image.

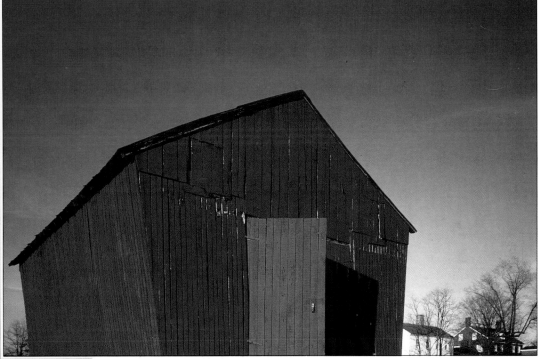

ABOVE The contrast between powerful reds and blues has been further helped here by the photographer's use of a polarizing filter, which has deepened the blue of the sky even further. Using slower films in these circumstances will result in even richer colours.

STRONG COLOUR

Perhaps because most everyday scenes tend to be subdued in colour, intense hues always attract attention. Unlike painting, in which the choice of colour and its richness is entirely under the artist's control, most photography is a matter of capturing scenes and incidents as they appear. The relative rarity of a flood of colour makes it a natural subject for the camera.

What makes a colour strong? If the end-result is to be a photograph, there are a number of factors, and some of them offer the photographer choice. More than anything, however, colour intensity depends on how pure the hue is. Pure colours are not tainted with black, grey or white, and the purest of all are those that are not mixed with any others. Colour film itself works by mixing three pure coloured dyes – cyan, magenta and yellow. These are known as primary colours for just this reason – most other colours can be created by mixing them. Film chemistry, however, is slightly different from the eye's colour perception, and the three normally recognized primaries are red, yellow and blue.

When the two primary colours are mixed together equally, they produce a secondary colour. These too are rich and strong, although slightly less so than the primaries; they are orange, green and violet. Further mixing makes for weaker hues. Now, in normal, straightforward photography there is little opportunity to create colours in this way, but the theory is important for knowing where to look for them.

In nature, and on a large scale, there are very few strong colours – greens, browns and greys are much more common. One major exception is a clear blue sky, but for the most part you need to look in detail for vivid hues – in flowers, for example. Man-made colours are a much easier source and include, for example, brightly painted shopfronts, automobiles and hoardings.

ABOVE Although a secondary colour, being a mixture of cyan and magenta, pink still has sufficient strength to carry this flowery image.

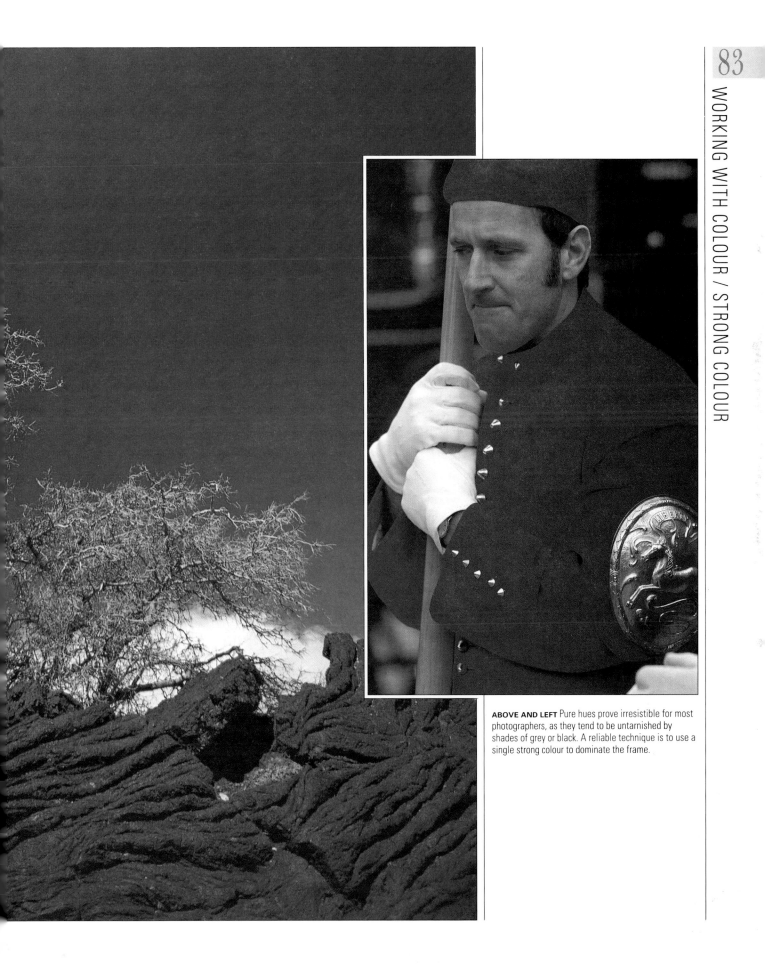

ABOVE AND LEFT Pure hues prove irresistible for most photographers, as they tend to be untarnished by shades of grey or black. A reliable technique is to use a single strong colour to dominate the frame.

ABOVE The red of this jacket is already strong, but it has been deepened further by using low-angle, warm sunlight. Colours such as yellow and orange also benefit from this kind of treatment.

RIGHT Strong frontal lighting, where the sun is behind the camera, makes colours richer than if they were shot backlit. Moving close in to the subject also accentuates the rich colour.

There are several techniques for making colours strong and insistent in photographs. One of the most obvious is to choose lenses and viewpoints that allow you to be selective. As we have already seen, large-scale views are not usually strongly covered overall, mainly because there is a large mixture of objects. Flowers growing at the edge of a wood become lost as you step further back. Closing in has the opposite effect. For this reason, both a macro lens and a telephoto can be used to isolate one or two strong colours from duller surroundings.

The lighting also plays a key role. If you use flash or other photographic lamps, you have complete control, but even in natural light you have the important option of waiting for the right angle of the sun, or better weather conditions. Generally, the best conditions for showing a colour at its most intense are full lighting with the least shadows and least reflections. If you look back to some of the examples of sunlit scenes, you can see that backlighting in various degrees is strong on atmosphere and depth, but weak on colour. Frontal lighting, however, with the sun behind the camera or slightly to one side, enhances colour richness. On the same principle, so does a camera-mounted flash, with the exception that a shiny surface is likely to throw back reflections that drown the colour.

Overcast weather that gives flat, diffused light can also give good colour intensity, simply because shadows and reflections are at a minimum. Because we are conditioned to think of dull light as being weak, the colour may not seem so strong, but, provided that you close in tightly on a single hue, it will be on the film.

Another control that you can exercise is over the amount of light – by means of exposure. As an exercise, take a bright, pure colour, and photograph it at several exposure settings. The darker exposures will be the most intense. Slide film is particularly good with this technique for increasing colour saturation.

ABOVE Fit a macro lens and a whole new world of strong colour opens up before you. Using a close-up lens helps isolate one or two strong colours, and careful composition helps eliminate potentially distracting hues from the scene.

LEFT When using slide film, try underexposing by between one half and one full stop to increase colour saturation. To test this, shoot several frames of a single scene at various exposures; the darker ones will feature the more intense hues.

BELOW Resisting the temptation to go for strong, vibrant bursts of colour can sometimes bring great rewards; the eye will appreciate the subtle changes in hue as it follows this crowd scene.

BELOW RIGHT 'Broken', limited colours can be more interesting than strong primary hues; the palette of colours presented to the viewer here is small, and yet the subtle changes have a graphic appeal often destroyed by dense, bright swathes of colour.

BROKEN COLOUR

Although strong colours have an immediate appeal, it can also be a short-lived one. Photographs that rely heavily on an intense area of colour often do not sustain a longer look. They depend on making a quick visual impact. The range of pure hues is limited, and this restricts the choice for exploring colour relationships.

In nature, most colours are impure, diluted with others and with blacks and greys to give a much more neutral range than the ones we have seen on the last few pages. Typical landscapes contain browns and other earthy colours, and greens tinged with yellows and blues. These 'broken' colours, as they are sometimes called, are subdued, but in some ways offer more interesting opportunities than strong primary hues. Because the palette is restricted, the eye becomes more sensitive to small differences between colours, and subtlety becomes the main appeal.

As with images in strong colours, the most important step here is to train the eye to see a limited range within an overall view. Being selective in this case means composing an image to exclude flashes of brighter colour that would be distracting. Because most people find it natural, when thinking about colour, to go for the obvious and definite, it takes a conscious effort to be restrained.

ABOVE Stones can be nature's source of both brilliant and subdued colour. Here, pale blues, pinks and ambers have been juxtaposed to form an arresting image.

LEFT Urban centres can appear drab and colourless. For the photographer, however, this can be turned into an advantage; even colours that would appear mundane in the countryside, such as the mauve of this railway carriage, can be used to great effect in the city.

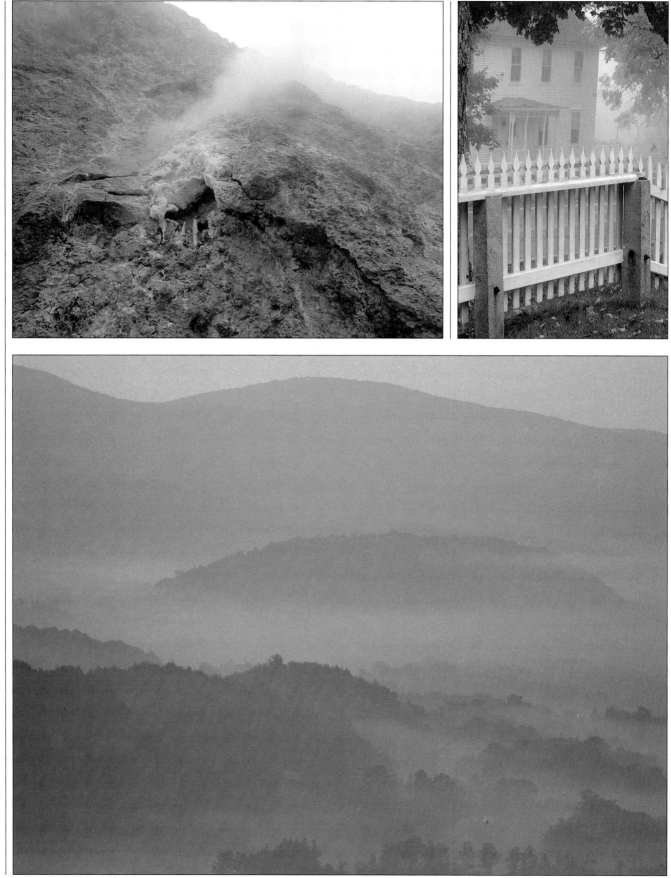

FAR LEFT Backlighting a subject can help to take the edge off strong hues, even in a scene such as this.

LEFT A natural atmospheric condition such as haze can be further aided by the use of a soft filter to dilute colours.

BELOW LEFT Subdued colours can be guaranteed with the combination of low-angle sunlight and a dense mist.

BELOW Shoot early or late in the day, choosing a viewpoint facing towards the sun. The yellow-to-red colour added by the sun itself early and late in the day can enhance the effect.

The palette of colours can also be limited by the quality of lighting, and this gives the photographer much more choice in the treatment of a scene. Outdoors, the angle of the sun, the weather conditions and the camera viewpoint all contribute to the effect. In addition, understated use of filters can be used to enhance the delicacy of some hues.

Any of the atmospheric conditions that screen a view, such as haze, mist, fog or smoke, drain some of the intensity of colour. At the extreme, a dense fog reduces the components of a scene to monochrome. Judicious choice of camera position can help in increasing the natural effect of haze and mist: shooting towards the light increases the scattering of light. If you also shoot without a lens shade, the flaring will further dilute colour intensity. The way in which the word 'atmospheric' is often used to suggest a heightened mood in a picture acknowledges this visual effect.

Even without the help of atmospheric conditions, the angle of the sun helps to control the colourfulness of a scene. As we saw with strong colours on previous pages, frontal illumination, with the sun or light source behind the camera, picks out hues very clearly. To achieve the opposite effect, use backlighting by shooting early or late in the day, from a viewpoint facing towards the sun. The effect is enhanced by the yellow-to-red colour that the low sun itself adds to the image.

Filters can mimic some of these effects; it is, in fact, much easier to dilute an image than it is to sharpen it, in detail, tone and colour. A mildly coloured filter has the effect of adding a slight wash to the photograph, without making it obvious that the photographer is manipulating the image. Any of the several softening filters – diffusers, soft-focus, fog, pastel, and so on – have an effect similar to backlit haze and mist.

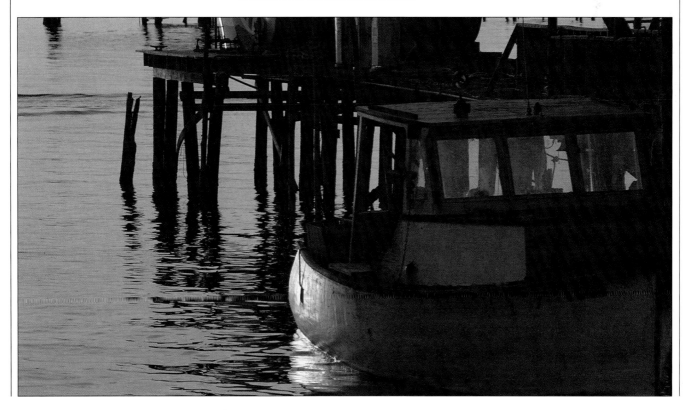

One of the most exciting parts of colour photography lies in the relationships between different hues. Most of the examples that we have seen in the last few pages have relied essentially on a single colour to carry the image. However, the sensation created by a colour changes when it is in the presence of other colours. Some blend together, others create tension, but all interact in some way. Knowing something of the theory of colour combinations will allow you to take extra control.

The basis of colour relationships is the colour wheel, used in one form or another by artists for centuries. This is closely, although not exactly, related to the spectrum of colours that can be seen in a rainbow, or whenever else white light is broken up into its parts. Imagine the spectrum that you can see being bent round so that it forms a circle of colour, like the one shown here. Going clockwise from red – one of the primary colours – the colour wheel progresses to the other primaries, green and blue, by way of the secondary colours in between. The way that this colour wheel is arranged is such that if all the colours are combined, they make white in the centre, and if any two opposite colours are combined, they too produce white. Opposite colours on the wheel are called complementaries.

The position of colours on this wheel give a clue as to how they will interact in an image. The simplest and most harmonious combinations are those of colours that are adjacent on the wheel. Just as they blend from one to another on the wheel (and, indeed, in a rainbow spectrum), so they seem to be a part of a close sequence in a photograph. This works in most examples, but there are exceptions to this. Very strong colours just a little distance apart on the wheel can clash – for example, a bright red against a bright magenta. In reality, the colour wheel should be a continuous progression of colours, and it is only for convenience that it is usually shown divided into segments. A sharp jump across a segment, without the muting effect of atmosphere or dilution, can cause a clash.

The Colour Wheel

This is really a simplified spectrum bent into a circle. As well as a guide to colour relationships as seen by the human eye, the colour wheel helps to explain what actually happens during colour reproduction. Any three equally spaced colours (blue, green and red for example) combined equally give white. In the subtractive process white light is selectively blocked by dyes or pigments: thus a yellow dye will block blue light, which is opposite yellow on the wheel.

BELOW This combination of magenta and red has been aided by the muted atmosphere of the shot.

LEFT Although it is undeniable that strong primary colours are attention-grabbers, muted secondary colours used in the right combination can be equally effective.

RIGHT A strong primary yellow can be pleasantly set off against a light brown.

BOTTOM Attractive images can be formed from the variations in shade of a single secondary colour, in this case green (a mixture of yellow and cyan).

RIGHT AND BELOW RIGHT These two scenes, on first impressions, couldn't appear further apart, both in approach and subject matter. Yet both make use of complementary colours; in the case of the shot of the 'Blackbird' aircraft (below right), orange and blue are used to bold advantage, while gold and blue are exploited in the photo of the wrapping to the foot of a lunar module (right).

COMPLEMENTARY COLOURS

A quite different way of combining colours is across the colour wheel. Any two colours that are directly opposite each other on the wheel have a special relationship to each other; if a painter were to mix them, they would produce a neutral tone, or if two lights of these colours were played onto the same surface, the result would be white. On the face of it, this relationship may seem to be more important to a painter than to a photographer, but in fact it underlies the harmony of what are called complementary colours.

The simplest version of the colour wheel is one that contains just six hues: three primaries and three secondaries. Opposite each primary is a secondary colour – for instance, orange lies opposite blue – and because they mix to a neutral grey or white, they balance each other. You can test this by taking two filters, such as red and green, and holding one over the other. Although this balance is a technical one, it is the reason why, to the eye, a combination of two such opposite colours in an image seems harmonious.

To get a completely balanced effect using complementary colours, one more thing needs to be considered – the relative brightness of each. Just a glance at the wheel shows that yellow is the brightest of the colours, and violet the darkest. So, to create an overall harmony in a picture that has these two complementaries, there needs to be considerably more of the violet than of the yellow – 4 to 1, in fact. In an orange and blue combination, the orange is brighter, although not to such an extreme degree; here, the harmonious relationship is about 3 to 1. Red and green, the final complementary pair, are evenly matched in brightness, and so combine perfectly in equal amounts.

Using viewpoint and focal length, it is often possible to frame a scene so that the colours are in particular proportions. This makes a very good exercise in working with colour relationships, but beware of thinking that there is something 'correct' in the combinations described here. There is nothing to prevent you from making a dramatic combination of colours that clash. Knowing these complementary relationships, however, will help you in deciding the amount of harmony or discord in a scene.

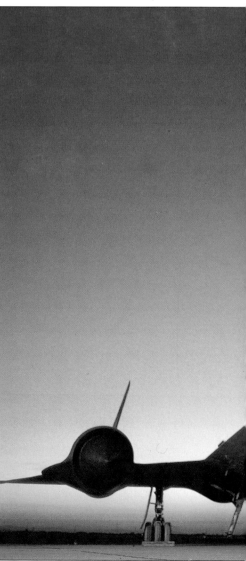

ABOVE LEFT An image can be given an extra boost by playing off two complementary colours – in this case yellow and blue – against the rich red, which gives the photo the depth that would otherwise be lacking.

ABOVE The relative brightness of complementary colours must also be taken into account when composing a scene; in this case, the potential strength of the yellow has been off-set by the depth of the blue.

ABOVE FAR LEFT Complementary colours can be employed even in subdued conditions to lift a photo above the ordinary.

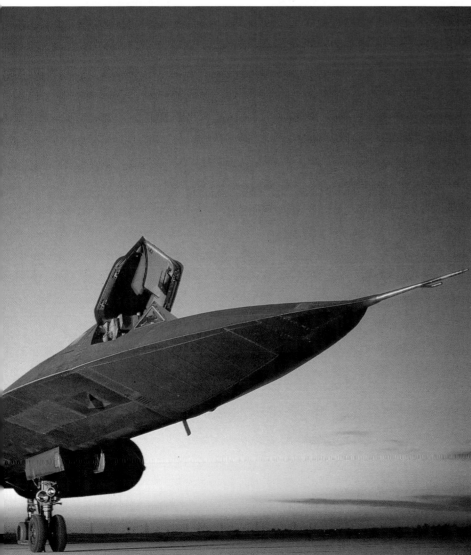

LEFT AND BELOW LEFT Two scenes that would most probably not warrant a second look if it were not for the simple addition of a small burst of colour. With these examples, the photographer adjusted the composition of the photo to accommodate the colour accent.

LEFT The dash of green in this shot is relatively unimportant if looked at in terms of its size in the frame, and yet the photograph would be lost without it. Imagine the picture without the small flash of colour; the blue would look bland and lifeless.

ABOVE LEFT Here, three subjects have been employed to draw the eye from the drab grey-green of the rest of the scene; the red bucket, the washing hanging up, and the bundle of clothes to the right. They interact to draw the eye from left to right.

COLOUR ACCENT

While the previous pages showed deliberate composition with complementaries, any image that contains more than one hue automatically has within it colour relationships. We saw how certain proportions of opposed colours created a particular kind of harmony, but in contrast to this, a small spot of colour creates another kind of colour energy. The relationship between the hues is then less important than the great difference in the size of the coloured areas in the frame.

One of the most obvious and useful ways of using a colour accent is in a landscape or setting that is drab and lacks colour. Many urban and industrial views, particularly under cloudy skies, have this appearance. A single spot of colour – from a brightly-clothed passer-by or a bunch of flowers, for instance – will enliven the photograph. Whereas the overall drabness of the setting might provide no focus of attention, and even discourage you from taking a photograph, a bright colour accent will change the whole structure of the view. It attracts attention and provides a visual counterpoint to its surroundings.

Any essentially monochrome view has the potential for using a colour accent. Other scenes that have a uniformity of hue include snow-blanketed landscapes and long-distance shots of rolling green fields. Photographed like this, they may well have a monochromatic beauty that stands well alone. There may, in other words, be good reasons for not attempting to add a spot of colour. If, however, you do include a colour accent, it will change the nature of the image considerably. Warm, bright colours are usually the most effective – splashes of red, orange or yellow. Nevertheless, beware of cliches: for example, a red-jacketed figure in a landscape has been over-used.

The colour psychology involved in this type of composition is such that the colour accent often works best when very small. By occupying a tiny part of the frame, it becomes unexpected, and fights for attention more strongly than if it were larger. Bear this in mind when choosing a camera position and selecting the focal length of lens – a wide-angle lens may be more suitable because it takes in a broader panorama.

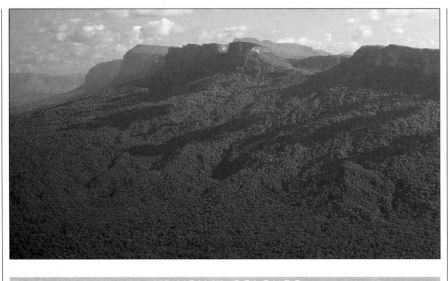

LEFT The strange mauve cast in this landscape is the result of the use of Kodak Infrared Ektachrome film, which is partly sensitive to infrared wavelengths. Infrared sensitivity can make exposure calculations a little tricky, so it is advisable to bracket.

BELOW Even colours that are not technically compatible can work if used boldly and in the right combination. Again, the colours are at the heart of the success of this picture.

UNUSUAL COLOURS

Colour can also play a very different role in a photograph – bringing a touch of strangeness to the image. Filters are probably the most obvious method, but the choice of film can also make a surprising difference.

The simplest way of doing this is to use a strongly coloured filter in a single hue. At a stroke, this changes the nature of the image, and there are no restrictions to the choice. The correction and balancing filters that we looked at earlier offer only a modest change, but those intended mainly for altering the response of black-and-white film are much more intense. These range from

primaries like red (25 in Kodak's Wratten series of gelatin filters), to more exotic hues such as the strong pink of a Wratten 32. An alternative that offers more control and greater possibilities for manipulation is a coloured graduated filter. In this design, only half of the filter is tinted, and the edge of the tint is soft, so that in use there is no hard visible edge to the colour. A typical application for graduated filters is for the addition of colour to the sky, with the colour fading away at the horizon.

The danger in making this kind of colour manipulation is that it is almost too easy to do, and as a result can be a meaningless exercise. After experimenting with a few filters to see the possibilities, it is important to discriminate in the photographs you apply it to. Always think first whether the image would be better treated normally. If you set up a slide duplicating system, as described on page 120, you may find that it gives you greater freedom to play with different colour treatments if you add coloured filters only when making copies of slides, not when shooting originals. When making prints, add the filters during enlargement, for the same reason.

One special type of film automatically gives a transposition of the normal colours in a scene. Infrared Ektachrome is a 'false-colour' film that is partly sensitive to infrared wavelengths, and has its three dye layers arranged unrealistically. While scientific uses are its main application, its pictorial effect is unusual enough to justify experimenting. Exposure calculations are a little difficult to make, because of its infrared sensitivity – ordinary exposure meters do not respond in the same way. It is best to bracket exposures. The main drawback with this film is that it must be processed in the outdated E-4 process. Only a few distributors stock the appropriate chemicals for this; their names are available from Kodak.

ABOVE AND BELOW It is important to use discretion in your choice of filters. For these two shots, for example, the strange colour casts occurred naturally, and did not need a filter to help matters. Note how colours that are not common – in this case shades of purple – can be used to dominate a photo, without the risk of the picture becoming mundane.

One of the special qualities of colour is that it can easily create a very subjective and emotional response. It is this that sets it apart in type from other graphic qualities such as shape, line, form and texture. They are all qualities that define an image, but colour goes further than this. The hue, or combination of hues, has particular associations for different people, and these can sometimes be very strong.

The reasons that underlie our often complex reactions to colours are a mixture of physiology and psychology, and the two are not always easy to separate. The physiological responses depend very much on the way our eyes and visual cortex operate. Of all wavelengths, the human eye is most sensitive to yellow-green (hence the tint of pilot's glasses). Because of this, yellow seems to us to be vibrant and active, while the hues to which the eye responds less well, such as blues and violets, seem more passive and quieter.

Psychological reactions depend on a host of experiences, from cultural to personal, and are not always consistent. However, there is little practical purpose in going deeply into this, as the uses to which you can put colour associations in a photograph are necessarily simple and uncomplicated. To get a response from a large number of viewers, the associations must be the most common. One of the most common of colour associations is the range from warm to cool. Blues and related hues are felt by most people to be cool, sombre and recessive; they fall naturally into the background. Reds and oranges, on the other hand, are more aggressive, stronger, hotter. A red-orange subject against a blue-green background can have an almost three-dimensional effect to the eye, with the warmer element thrusting forward toward the viewer.

There is also a difference in association between rich and pale colours. Paleness is associated with delicacy and weakness, richness with stridency and a lack of subtlety. True skill in the management of colour in photography comes through understanding the full range of emotional associations of colours, coupled with the ability to take advantage of the opportunities that offer themselves.

ABOVE Despite the rather subdued content of this picture, the colours demand the viewer's attention. The strong, rich red spells out heat and immediacy, almost danger; all qualities that are at odds with the activity of the subject.

LEFT The dominant colour in this image – blue – complements the subject matter perfectly. We translate blue as cool and calming, falling naturally into the background.

RIGHT A powerful image that relies largely upon strength of colour for impact; the eye sees the rich orange as strong and aggressive, lending the image a dimension which, relying upon composition alone, would be lacking.

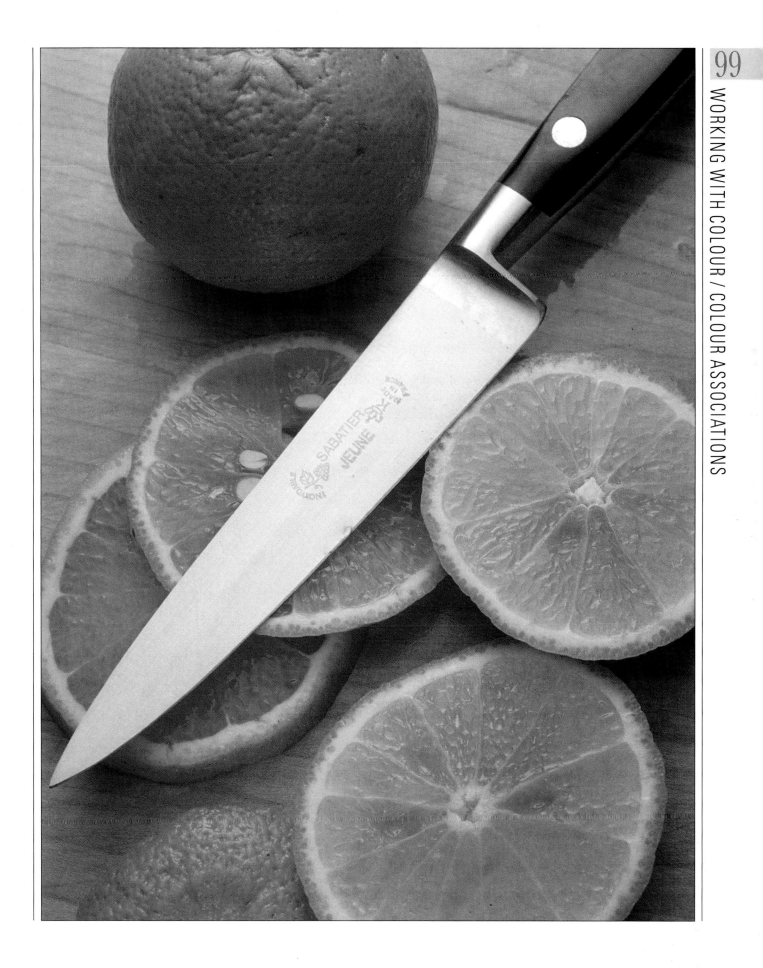

COLOUR NEGATIVES

Look back to the recommended equipment section. First make sure that the colour negative film you have shot matches the processing kit; the majority of colour negative films are compatible with Kodak's C-41 process. The names of processing kits also vary, so check the packed information. The example used here is the Kodak Flexicolor Kit, which contains one pint of each solution except the developer, of which there are two pints. The solutions are in the form of liquid concentrates and powder.

First prepare the solutions according to the instructions. With those chemicals that are supplied in two parts, mix each part one at a time, not both together. Once prepared, the solutions should be stored in tightly stoppered bottles. The life of most solutions is about six or eight weeks, so mix them only when you need them.

Load the film, in darkness, onto the spiral reel. Make sure that the reel is the right width for the film you are using or, if it is an adjustable plastic reel, that it is set to the proper width (twist the two halves and then lock them into position). With a stainless steel reel, clip the end of the film onto the core of the reel, then turn the reel in one hand while pressing the sides of the film in gently with the other, so that the film feeds into the grooves from the inside outwards. With a plastic reel, push the film onto the grooves from the outside, so that it slides inwards to the centre. When the film has been loaded, place the reel inside the tank and replace the lid securely.

Next bring the solutions to working temperature. For the developer at least, this must be very accurately maintained, at 37.8°C (100°F) with no more than a 0.15°C (0.4°F) variation. The other solutions can be between 24 and 40.5°C (75 and 105°F), so it is usually easiest to warm everything to the temperature of the developer. The simplest method is to fill a deep tray with warm water and place the solution containers in this. It will take a short time (about 10 minutes) for the solutions to reach the right temperature, so that the bath should start a degree or two warmer than 37.8°C. Keep a constant eye on the thermometer, and stir the developer as it warms up.

Each of the processing steps requires a similar procedure: pouring the solution into the tank, starting the timer, agitating the tank, and finally pouring the solution away (either down the sink or back into its storage bottle, depending on the solution). Develop a consistent way of doing all this, so that the results are predictable and repeatable. For instance, start the timer when you have just finished pouring the solution in, and begin draining it away so that the last drop leaves the tank as the timer stops. If in doubt, practise with an empty tank and plain water. It should take about 10 seconds to drain out the liquid. Also, each time you pour a new solution into the tank, make a habit of tapping the whole tank against a hard surface to dislodge any air bubbles that might have become trapped on the film; this is particularly important with the developer, as it is being poured onto dry film.

Agitation is essential, and it must be done in a certain way to make sure that the film is acted on evenly, especially with the developer. There are two principal ways: inverting the tank or sliding it in a pattern on the worktop. Follow the diagram instructions, and if you invert it (the normal method), be sure to hold the lid and cap tightly to prevent spillage. Do not agitate continuously, but follow the sequence shown in the table.

Processing KODACOLOR II and KODACOLOR 400 Films in the KODAK FLEXICOLOR Process Kit for Process C-41

1 US Pint/473ml/16 fl oz Size

PROCESSING STEP	MINUTES*	°F	°C	AGITATION (SECONDS)		
				INITIAL	REST	AGITATION
1. Developer	3¼	100 ± ¼	37.8 ± 0.15	30	13	2
2. Bleach	6½	75–105	24–40.5	30	25	5
Remaining steps can be done in normal room light.						
3. Wash	3¼	75–105	24–40.5			
4. Fixer	6½	75–105	24–40.5	30	25	5
5. Wash	3¼	75–105	24–40.5			
6. Stabilizer	1½	75–105	24–40.5	30		
7. Drying	10–20	75–110	24–43.5			
Includes 10-second drain time in each step.						

Processing KODAK EKTACOLOR 74 RC Paper in the KODAK Rapid Color Processor, Model 11

PROCESSING STEP	MINUTES
1. Prewet (water)	½*
2. Developer	2
3. First Wash	½
4. Bleach-Fix	1
5. Second Wash	½

*Includes drain time of 10 seconds;
5 seconds for the other steps.

Preserving chemicals

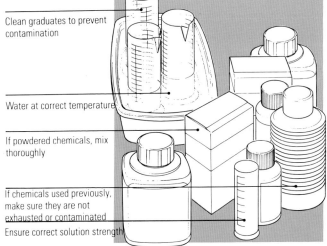

Clean graduates to prevent contamination

Water at correct temperature

If powdered chemicals, mix thoroughly

If chemicals used previously, make sure they are not exhausted or contaminated

Ensure correct solution strength

Loading film

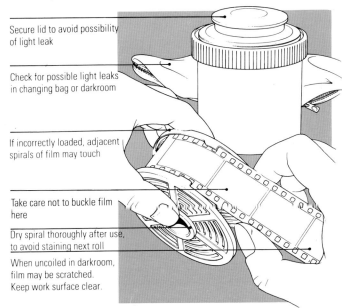

Secure lid to avoid possibility of light leak

Check for possible light leaks in changing bag or darkroom

If incorrectly loaded, adjacent spirals of film may touch

Take care not to buckle film here

Dry spiral thoroughly after use, to avoid staining next roll

When uncoiled in darkroom, film may be scratched. Keep work surface clear.

Processing

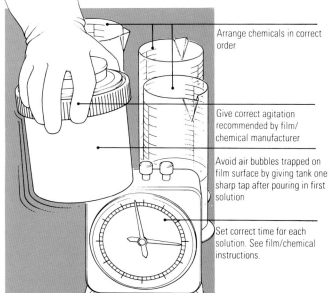

Arrange chemicals in correct order

Give correct agitation recommended by film/ chemical manufacturer

Avoid air bubbles trapped on film surface by giving tank one sharp tap after pouring in first solution

Set correct time for each solution. See film/chemical instructions.

1 If using a stainless steel reel attach the end of the film to the spike or clip at the core and rotate the reel to thread the film into the grooves. Always hold the film by its edges, and bow it carefully to fit it into the reel.

2 Cut the end of the film off the spool, lower the fully loaded reel into the developer tank and replace the lid. It is now safe to turn on the light.

After the developer, add the bleach. The temperature is less critical for this solution, but the film must still be in complete darkness. After the bleach, the other steps can be done in normal room lighting, but as you will still need to agitate the tank, it is usually more convenient to keep the lid on the tank. However, if you are eager to check the results, you can examine a few frames of the film about halfway into the fixing step.

After the final wash and stabilizer, attach a film clip to the end of the film, draw the entire length of film out from the reel, and hang it up to dry (a clothes line is convenient). Weight the bottom end of the film with a second clip and draw a squeegee or soft sponge, dipped in wetting agent, down the film from top to bottom. This action avoids spots and drying marks. Dry for at least 20 minutes in a dust-free room.

3 Re-check the developer temperature and pour it quickly into the tank. Tap the tank lightly to disperse any air bubbles and fit the cap that covers the hole in the lid.

4 Start the time (preset for development time). For 15 seconds in every minute of development agitate the tank by rocking it backwards and forwards. This will ensure that the developer acts on all the film.

5 Quickly pour out the developer at the end of development time and pour in the stop bath. Agitate continuously for 30 seconds. Pour out the stop bath and refill the tank with fixer.

6 At the end of the time recommended by the manufacturer, pour out the fixer. Attach the filtered hose to a cold tap, the other end to the core of the reel, and wash for at least 30 minutes in *gently* running water. Strong water pressure may damage the film.

Washing and Drying

7 Add a few drops of wetting agent (to avoid drying streaks) before removing the reel. Unreel the film, attach it to a drying clip and use the squeegee tongs to remove excess moisture. Hang up to dry in a dust- and draught-free area.

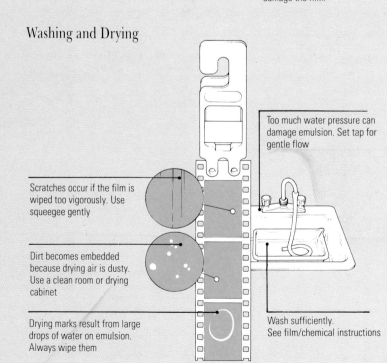

Too much water pressure can damage emulsion. Set tap for gentle flow

Scratches occur if the film is wiped too vigorously. Use squeegee gently

Dirt becomes embedded because drying air is dusty. Use a clean room or drying cabinet

Drying marks result from large drops of water on emulsion. Always wipe them

Wash sufficiently. See film/chemical instructions

1 An example of underdeveloped film; the image is too dark. On a negative, it would appear to be too pale.

2 An example of overdeveloped film; the same pale image can be caused by overexposure when taking the shot. The film speed may have been too slow.

BELOW It is of course easier to spot problems on the negative after development with large format cameras than with 35mm. The contrast on this negative looks excellent.

3 Gross underexposure; the transparency would appear to be almost black, the negative almost transparent. This is probably caused by a faulty shutter rather than any error on the photographer's part.

4 Unexposed film; the negative would be transparent and the transparency black. The film may not have been through the camera if the film tongue was not attached securely to the spool. Or perhaps a very high shutter speed was used with flash.

Many of the processing methods are the same for slide film as for negatives, although there are more steps. The reason for the extra steps is that, part way through the processing sequence, the image must be reversed so that the result is a transparency rather than a negative. Once again, first make sure that the film you are using can be processed in the chemicals; the standard process is Kodak's E-6, which is the example that we use here. Load the film into its tank, mix and prepare the solutions in the same way as described for colour negative films.

There are two developers in this process, one used at the beginning, the other used after the reversal bath. Both need to be used at the same precise temperature as the developer for colour negatives 37.8°C (100°F). The tolerances are also very tight: 0.3°C (0.5°F) for the first developer, 1.1°C (2°F) for the second developer. The remaining solutions are less demanding, but must be used between 33.5 and 39°C (92 and 102°F). Control the temperature in the same way as for colour negatives, but be a little more careful in maintaining the temperature of the bath after you have added the first developer – remember that the second developer, a few steps later, must also be at exactly 37.8°C (100°F).

Follow the procedures already described for colour negatives, using the table shown here for timings and steps. At the end, as you hang the film up to dry, it will be slightly milky, but this will clear as it dries. Only judge the quality of the results when the film is completely dry. A hair dryer will speed up this part of the process, but be careful not to overheat the film; do not exceed 50°C (122°F) to avoid distortion.

ABOVE E6 slide films can be used at a higher speed than their recommended rating, as long as the development is extended accordingly. This can be particularly useful to photographers working with transparency film in low light conditions. This shot was push-processed.

Processing KODAK EKTACHROME Films in Process E-6
For 1 US Pint/473ml/16 fl oz Processing Tanks

PROCESSING STEP	MINUTES*	°F	°C	AGITATION (SECONDS)		
				INITIAL	REST	AGITATE
1. First Developer	7†	100 ± ½	37.8 ± 0.3	30	15	5
2. Wash	1	92–102	33.5–39	30	15	5
3. Wash	1	92–102	33.5–39	30	15	5
4. Reversal Bath	2	92–102	33.5–39	30	80	–
Remaining steps can be done in normal room light.						
5. Colour Developer	6	100 ± 2	37.8 ± 1.1	30	25	5
6. Conditioner	2	92–102	33.5–39	30	80	–
7. Bleach	7	92–102	33.5–39	30	25	5
8. Fixer	4	92–102	33.5–39	30	25	5
9. Wash (running water)	6	92–102	33.5–39	30	25	5
10. Stabilizer	1	92–102	33.5–39	30	20	–
11. Drying	10–20	75–120	24–49			

Includes time required to drain tank (usually about 10 seconds).

For initial films through a 1 pint (473ml) set of solutions.

See instructions accompanying the kit for Process E-6 for development times of subsequent films through the same set of solutions.

▮ PUSH-PROCESSING

You can use E-6 slide films at a higher speed than their normal rating, provided that you extend the development. This can be very useful in low-light conditions. Simply treat the film as if it had a higher ISO when you shoot, and make a note on the film cassette to give it extra development. For example, you can use Ektachrome 400 film as if it were ISO 800 and gain an extra stop. To achieve this extra 1-stop increase, add 2 minutes to the first developer time (continue the pattern of agitation for these extra 2 minutes). That is all there is to it. For a 2-stop increase, add 5½ minutes to the first developer. There will be some increase in graininess and contrast, and a slight change in colour, but with a 1-stop increase these are not likely to be great.

When overdeveloping – 'push processing' – or underdeveloping – known as 'cutting' – perhaps in an attempt to compensate for exposure error or high/low light levels at the time of the shoot, you will not always know by how much to over- or underdevelop. As a test, it is possible to take a short length of film from the beginning of the roll. In the dark, cut off sufficient film to include two or three frames and develop this test clip normally. By 'sacrificing' the first frames of the roll like this, you can then decide whether to 'push' – as in the photograph below right – or 'cut' – as in the print bottom right. The main picture, taken with a 400mm telephoto lens (1/60sec, f16) was developed normally. The others were over- and underdeveloped by one stop respectively.

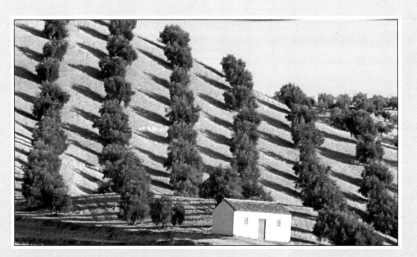

Compare the contrast in the photograph above, developed normally, with that in the examples below (400mm, 1/60sec, f16).

This photograph has been 'pushed', or overdeveloped by one stop.

This version has been 'cut', or under-developed by one stop.

ASSESSING THE RESULTS

Professional laboratories use control strips of pre-exposed film to monitor their processing. If you process your own films individually and occasionally, however, you should examine the results carefully to make sure that there have been no mistakes. If there is anything wrong with the film, it could have occurred either during the processing or earlier, when taking the photographs.

Of the two types of film, negative and slide, the first is more difficult to judge. Slide film, once processed, carries its image as it should be seen, and can be assessed by using a light-box, projector or slide-viewer. In a colour negative, however, both the tones and the colours are reversed. In addition, a built-in orange mask is included by the manufacturer to improve print quality. This mask overlays everything.

A well-exposed colour negative looks rather denser than an equivalent black-and-white negative. If you view it through an orange filter (such as an 85B or similar), this will give a better idea of the tones. Nothing short of a print, however, will show what the colours will look like. One of the most common faults is under-exposure; others are fogging because of a light leak, stains due to chemical contamination, and scratches. Fogging appears as a dark area, and extends over the rebates (the perforated margins of 35mm film); it can occur during the loading of the tank, by failing to seal the tank's lid properly, or even earlier, if the camera back is accidentally opened before the film has been completely re-wound. If you develop one film at a time, you may have some opportunity to correct mistakes after the first has been processed. With the C-41 process, if you know that the films have been underexposed by one stop, increase the development time by one third. This is really an emergency procedure, as colour negative films are not designed to perform as well as slide films do when push-processed.

Mistakes in processing slide film are easier to spot. Look for over-exposure and under-exposure, but realize that this may have been a mistake during shooting. Strong colour casts and stains are probably due to chemical contamination; just a drop or two of bleach or fixer in the developer will have disastrous results.

TOP LEFT AND ABOVE Colour slide film is far more critical of exposure than colour negative film, a fact that must be remembered when assessing your prints from slides. Much of the time, slight under- or overexposure may be the fault of the original transparency. However, stains and noticeable colour casts may well be due to chemical contamination; a mere drop or two of bleach or fixer in the developer will have disastrous consequences. One thing you can't do much about, however, is an image which is simply out-of-focus. This can be spotted if you look carefully at the slide.

LEFT A well-exposed negative looks rather denser than an equivalent black and white negative. Viewing the negative through an orange filter, such as an 85B, will give a better idea of tones.

LEFT AND ABOVE A high-contrast scene such as this could be ruined completely by the common fault of print under-exposure; all detail in the foreground subject could easily be lost altogether.

BELOW Crimp marks show up as pinkish or bluish crescents on transparencies. These are most often caused by buckling the film before processing. Take care when separating the film from the spool and loading it into the developing tank.

COLOUR PHOTOGRAPHY

Although the colour filtration and exposure times vary from process to process, the essentials of making a colour enlargement are fairly standard. At the start, it may take you several tries before you arrive close to the best filtrations and exposures; the light output and optical parts of enlargers differ. If you use a simple enlarger with a black-and-white head, place a UV-absorbing 2B or CP2B filter permanently under the light head and above the negative carrier.

The first step after processing the film is to select the negatives or slides for printing. With slides, a light-box is sufficient to judge a well-exposed frame, but with negatives, make a contact sheet. As well as giving you your first look at the images, it will serve as a filing reference for later printing. Set the enlarger head at a height that will illuminate an area slightly larger than a 8×10-in (20×26-cm) sheet of paper with the negative carrier empty. Judging the exposure and filtration is something of a chicken-and-egg situation, because you must first have some experience with the enlarger and negative/paper combination that you regularly use. After you have set up your system for the first time, this will be no problem; for now, assume that you have calibrated everything. Set the filtration, aperture and timer according to previous test prints. Place one film, cut into strips of six frames each, in a contact-printer or under a plain sheet of glass. In safelighting, place a sheet of printing paper underneath and expose.

Having selected a negative or slide to print, place it in the negative carrier with the emulsion side down, facing the lens. Place the negative carrier in the enlarger, switch on the enlarger light, open the aperture fully, and adjust the head so that the image is composed on the easel according to your requirements and is in focus. This is easier to do if the room lights are switched off. To substitute for the thickness of the printing paper, place a piece of white paper in the easel for this step.

Select the filtration and lens aperture as recommended by the paper manufacturer. With slide printing, there will also be a difference depending on which brand of original film you used; Kodachrome will need less cyan and a little less magenta than will Ektachrome. Under safelighting or in total darkness replace the blank paper in the easel with a sheet of unexposed printing paper, emulsion side up.

Make a series of test exposures at intervals of five seconds. Use a piece of dark card to cover all of the paper except for a strip. With each successive exposure, uncover another strip. This first test print can then be used, once processed, to determine the best exposure and filtration for the final print. When you come to make this final print, the basic steps are the same. Keep a note of the settings that give you the best result; this will save time and paper if you come to make another print of the same photograph.

ABOVE Selecting the filtration and lens aperture for slide printing depends upon the brand of film. Kodachrome (above) will need less cyan and a little less magenta than will Ektachrome.

BELOW RIGHT An example of a test print, from which to assess the best filtration and exposure for the final print.

The test strip procedure

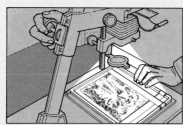

1 Place the negative in the enlarger's negative carrier (emulsion side down), cleaning off any dust preferably with an antistatic brush or a blower.

2 Insert the carrier in the enlarger head. With the room lights out, the enlarger lamp on and the lens aperture wide open, adjust the enlarger head until the image is focused and to the size you have chosen.

3 Make fine adjustments to the focus until the image is critically sharp. You can do this by eye or by using a focus magnifier which enables you to check the sharpness of the film's grain; (Irrespective of whether the image is sharp, as long as the grain is focused you will have the sharpest print possible).

4 Close down the lens aperture about two stops (normally this would be f11). With a negative of normal density this will let you use reasonably short exposure times, and the lens performance will be at its peak. The increased depth of field will also compensate for slight focusing errors.

5 Under safelight illumination, and with the enlarger lamp off, insert a sheet of normal (Grade 2) paper, emulsion side up, into the printing frame. Set the timer to five seconds.

6 Hold a piece of black card over the sheet of paper, leaving just a quarter of its width exposed, and give a five-second exposure. Move the card along for second exposure of five seconds. Make third and fourth in the same way. The whole sheet will be exposed for the final exposure. Process as an ordinary print.

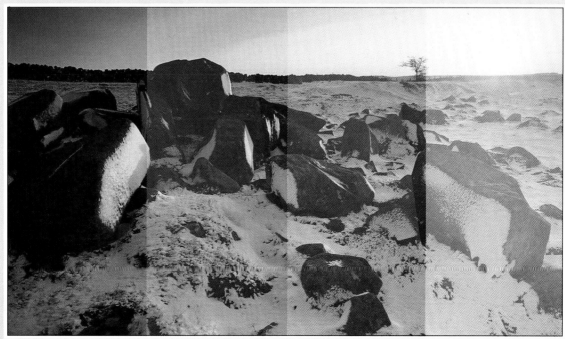

COLOUR NEGATIVE PRINTS

Temperature and agitation are important when processing the paper – much more so than in black-and-white printing. This is one reason why drum processing is highly recommended. The alternative is to use trays, but their size makes it more difficult to maintain good temperature control. The example shown is of Ektacolor processed in Ektaprint chemicals. The recommended temperatures for all the solutions is 32.8°C (91°F), with a variation of no more than 0.3°C (0.5°F). You can work at lower temperatures, but this will affect the processing time, and it is better to be consistent so that you can repeat the processing sequence with confidence every time.

First prepare the solutions according to the instructions. With drum processing, there is a pre-wet step at the beginning to soften the paper emulsion and warm it up. This helps the developer to penetrate quickly and evenly, but it also means that the developer will have to be more concentrated than it would for tray processing. See the packed instructions.

Place the correct volume of each solution in a container, and place these containers in a deep warm water bath. Because the room temperature will be less than that of the processing solutions, they will cool gradually. Start with the water bath several degrees higher than the 32.8°C (91°F) needed. When the solutions reach the correct temperature, take the first and pour it into the drum (already loaded with a sheet of exposed paper).

Agitate the drum according to the drum manufacturer's recommendation. A motorized roller, although an extra expense, does this without any attention from the photographer, and is a great help. As with film processing, start the timer when all the solution is in the drum, and start to drain it away at the end so that the drum is emptied as the timer stops. Do not keep any of the used chemicals – throw them all away.

ABOVE For convenience, and to avoid performing all steps in darkness, a print tube can be used for colour papers. This makes economical use of the more expensive colour chemicals, and is designed to be rotated through a bath of water thermostatically controlled at a constant temperature.

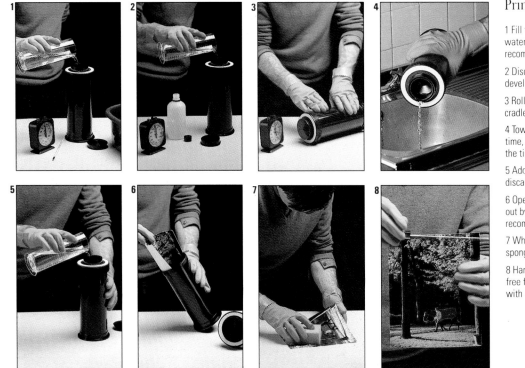

Print Processing

1 Fill the print-loaded tube with warm water to bring the contents to the recommended temperature.

2 Discard the water and add pre-warmed developer, starting the timer.

3 Roll the tube by hand or on a motorized cradle to ensure even development.

4 Towards the end of the recommended time, discard so that the tube empties as the timer comes to a stop.

5 Add the bleach/fix, roll the tube as in 3, discard and refill with warm water.

6 Open the tube, pull the paper carefully out by its edge, and wash as recommended. Clean the tube.

7 When the wash is complete, gently sponge excess water off the print.

8 Hang the print to dry in a room that is free from dust. Drying can be accelerated with a hairdryer.

For the washing steps, either refill the drum each time, or remove the print and place it in an open tray, replacing the water every 30 seconds. In either case, continue to agitate. To dry, place the print on a smooth surface, image-side up, and remove all drops of water with a wide squeegee. Then, hang it from a clothes line by a clip attached to one corner, or place it on a clean towel, image-side up. A hair dryer will speed up the drying process.

BELOW AND BELOW LEFT More so than with black-and-white printing, temperature and agitation are important when processing colour paper. Your target when making a print depends upon personal taste – accuracy may be sacrificed for the sake of richer, deeper colours. Large format cameras which give 4×5in negatives will always produce a finer print, which is why professional photographers tend to use them whenever possible. As always for the amateur, there must be a trade-off between the relative improvement in quality and the greater expense of equipment.

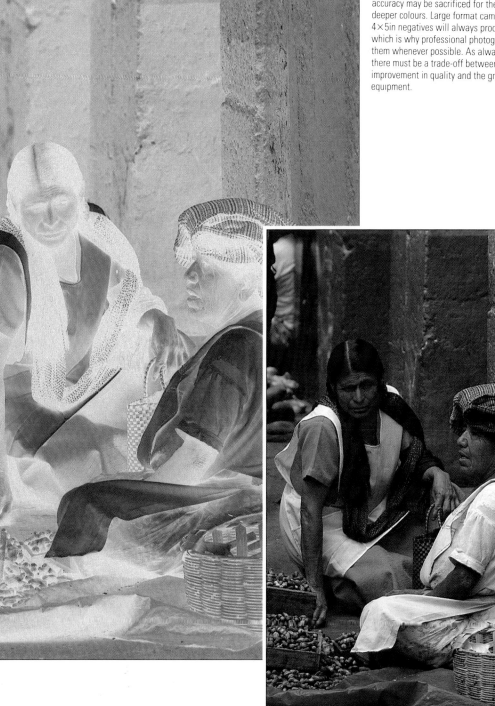

Colour transparencies can be printed directly onto paper, using the same techniques described for colour negatives. The main difference is that, because a positive image is being made from another positive image, there are extra steps in the process, just as there are in processing colour slide film. Also, any changes to the filtration and exposure are the opposite of those for colour negative printing. When making a print directly from a slide, more light from the enlarger gives a lighter image and adding a filter of one colour gives an increase in same colour to the printed image. The edges of the print, if they have been held down normally by the frame in the easel, appear black.

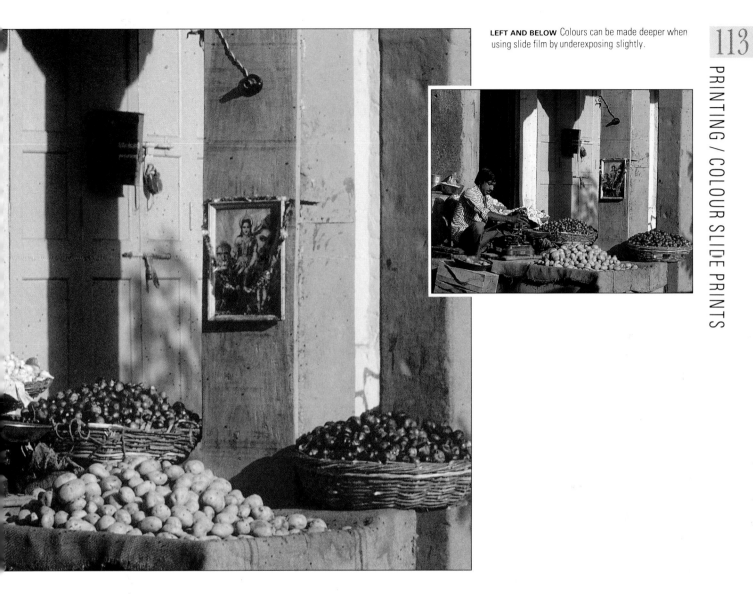

LEFT AND BELOW Colours can be made deeper when using slide film by underexposing slightly.

ABOVE LEFT AND BELOW LEFT Kodachrome has a very high blue sensitivity. In these pictures, the yellow cast from the setting sun (below) has been counteracted by the blue sensitivity of Kodachrome (above).

Most of the same equipment chosen for printing negatives can be used here. One difference is in the selection of printing filters, if you do not have a dial-in colour head on your enlarger. Cyan filters are often needed, so make sure that you have a selection of these, in different strengths. As with the negative printing process described earlier, a drum is recommended for ease and convenience. In fact, the need for absolute darkness when handling the paper also makes it safer.

The preparation and exposure stages are the same as for a colour negative, but see page 119 for the filter and exposure changes needed when you make corrections after the initial test print. Kodachrome slides, which are different in chemistry from other E-6 films, will need different filter packs when printing.

Mix and warm up the solutions as described on page 110. There are more of these than in negative printing, so make sure that the water bath is large enough for all the containers. Take the same precautions in maintaining the correct temperature: 37.8°C (100°F) with a variation of no more than 0.3°C (0.5°F). Follow the instructions step by step. As the print is hung up to dry, it will have a bluish cast, but this will clear during drying. Do not try to evaluate the print until it is quite dry.

An alternative process for printing directly from colour slides is Cibachrome. This works on a quite different principle from reversal processing, and is, on the whole, simpler. The coloured dyes that make up the final image in the print are already present in the paper, and so are rich and long-lasting. There are just five steps in the processing, including a water rinse after the development

Starting with Cibachrome

1 Begin by preparing the solutions as described in the leaflet supplied with the chemicals.

2 Put a slide in the enlarger and compose the image on the baseboard.

6 In the light, measure out 75ml of each solution including the rinse water, ensuring that they are all up to temperature (24°C).

7 Pour the developer into the drum, lay it on a flat surface and roll the drum back and forth for 3 minutes. Rinse for 30 seconds, bleach for 3 minutes and fix for 3 minutes.

8 Pour used solutions into a container or retain in separate bottles if required for reuse.

and a final water wash. The chemical kit – either Process P-30 or P-30 P – is available in two litre and five litre packs; but as each sachet of chemical contains enough to make up a solution of exactly one litre, it is not necessary to make up the full amount. Do not, however, try to split up sachets. There are two paper types, one with a lustre finish (Cibachrome-A II CRCA.44M), the other with a gloss finish (Cibachrome-A II CPSA.1K).

3 Take the recommended filters from the CIBACHROME-A filter set, together with the uv filter, and put them into the filter drawer of the enlarger.

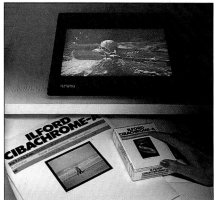

4 Turn off room lights and expose an 8×10in (20× 25cm) sheet.

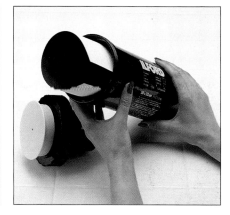

5 While still in the dark, insert the exposed sheet, emulsion facing inwards, into a clean dry drum. Close the drum.

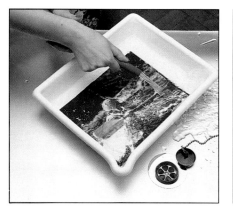

9 At the end of the processing sequence, carefully remove the print from the drum and wash it in running water for 3 minutes.

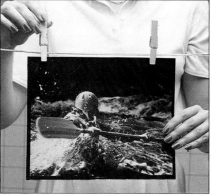

10 Hang the print up to dry at room temperature. Alternatively, place it on an absorbent surface or use a hairdryer.

BELOW RIGHT The contrast range of a colour print can be adjusted using two techniques; dodging and burning-in. In this scene, the brightness of the sky has been lessened at the very top of the frame by preventing light from reaching the Cibachrome paper.

By following the steps so far, you should be able to reach the point of having a print that is a close approximation to either the slide, or to what you consider the right treatment for the negative. There is, however, quite a bit more that can be done to control the final appearance of the print, and the techniques allow you considerable room for experiment. There is not the same degree of flexibility as in printing black-and-white photographs, but enough to be useful.

A high-contrast image is one of the classic problems in photography. The subject of the image is interesting, the view well-composed, but despite care in selecting the exposure when shooting, there is an insurmountable difference between the brightness of important parts of the scene. If the bright areas are rendered correctly, the shadows may be too dark, and conceal needed detail. Conversely, the right exposure of the shadows gives washed-out highlights. With colour printing there is, unfortunately, no choice of contrast grade in the paper, as there is for black-and-white. The answer is to give different exposure during the enlargement to different parts of the image.

There are two procedures: burning-in to give extra exposure to a selected area of the print; and dodging, to hold back the light from another area. In a complicated print, you may need to do both, in addition to a basic overall exposure for the rest of the image, but usually it is a matter of selecting one of the two techniques.

▮ BURNING-IN

To do this, you will need to restrict the light from the enlarger head in the form of a hole, the shape of which should correspond with the area you want to affect. Either cut a hole in a sheet of black card and suspend this over the print, or cup your hands for a similar effect. It is important to move the hole around constantly, to prevent the edges of the extra exposure being too obvious on the print. When printing a negative, this technique will darken an area; when printing a slide, it will lighten an area.

Printing-in with hands

For shading broad areas and for printing-in, hands are sometimes the most useful of all tools. By flexing and altering their shape as well as moving them over the print, complex and subtle results are possible (1, 2). When printing-in, be careful not to allow light to spill around the edges of the hands – raise them to cover a larger area or surround the edges of the paper with black card (3, 4). Burning-in is often done with cupped hands, in which case a foot switch is needed to operate the enlarger light.

▌ DODGING

In dodging, you block the light reaching an area. With a negative, this lightens the area; with a slide, it darkens it. The tools are shapes cut from black card stuck onto the ends of wire (proprietary tools are also available). For larger areas, you can use your hand, bunched into the appropriate shape.

▌ LOCAL COLOUR CONTROL

Once you have mastered the skills of dodging and burning-in, try a similar procedure with colour. The colour ring-around shown on page 119 may indicate that a selected area of the print could do with a slight colour change; for instance, you might want to increase the warmth of an evening sky. To do this, use a filter in the same way that you would use a dodging tool. When printing a negative, use the complementary colour to the one you want to introduce in the image; with a slide, use the same colour of filter.

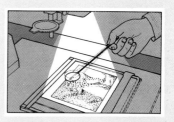

ABOVE For a smaller area, a dodging tool is used. This can be shaped to fit the exact area to be dodged. Hold it well above the print to cast an out-of-focus shadow and keep it moving.

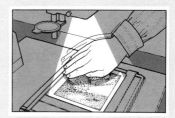

ABOVE Moving your hand continuously will give a soft edge to the shading.

Particularly when you start printing, it is unlikely that you will get both the exposure and filtration right first time. Colour is, in any case, a subjective variable, and at the printing stage you may decide to alter the balance. Judging the results after printing a slide is easier than from a negative, as the original slide is at hand for direct comparison. A negative, on the other hand, can only be judged properly for colour once it has been printed, so that there is no absolute reference standard. In either case, it is a good idea to tackle the assessment in two stages. First, judge the exposure, then the colour balance.

The test print will give you a series of exposures to choose from. Keep a note on the back of the test print of the enlarger settings; if you followed the recommendations given on page 109, the shortest exposure will have been five seconds and for each adjacent strip an additional five seconds. Remember that extra exposure, when printing from a negative, gives a darker image, while extra exposure with a slide results in a paler print. Look for clean highlights and rich, dark shadow areas, with the majority of tones in a typical scene having average density.

Next assess the colour balance. With experience, it is fairly easy to see in which direction the image has drifted away from neutral, but it helps at the start to have a reference.

It does not matter that the images are different; look for the same degree of colour imbalance and read the filter recommendation alongside. As you can see, negatives and slides need opposite filtration adjustment.

An alternative method is to use one of several proprietary kits for finding the best filtration. One useful tip for when you start printing for the first time, with an unfamiliar enlarger and paper, is to take a photograph that contains the two easiest colours to judge – neutral grey and average skin tones. We are so familiar with these that our eyes can discriminate colour shifts without difficulty. An 18% grey card (used for reflected exposure metering) is ideal. The prints can then be compared next to this.

Making a filtration test

Use the exposure test as a basis for estimating the likely filtration. Accurate estimation at this stage comes with experience, but at the start you may find it easier to try a few different filtrations (right). Do not make the changes too great, and remember to compensate in exposure for filtration changes. Make three or four exposures with different filter combinations.

Red bias

Green bias

Correctly balanced

These strips of different colour filtrations (below) show the effects of using varying strengths of the primary and complementary filters. Many printers make their own customized colour cast identification chart called a ringaround. This is a series of prints made at different, known filtrations from a very well exposed negative. To make your own, start with a 'perfect' print from the chosen negative, then make a series of prints, changing the filtration in units of ten up to 30 or 40 units in each of the filter colours. Mark the prints for reference.

This table shows filter factors from which you can calculate your new exposure to allow for filter changes – divide your original time by the factor(s) for the filter(s) you have removed. Then multiply the result by the factor(s) for each filter you have added and round off your result to the nearest second.

Filter	Factor	Filter	Factor	Filter	Factor	Filter	Factor	Filter	Factor	Filter	Factor
05Y	1.1	05M	1.2	05C	1.1	05R	1.2	05G	1.1	05B	1.1
10Y	1.1	10M	1.3	10C	1.2	10R	1.3	10G	1.2	10B	1.3
20Y	1.1	20M	1.5	20C	1.3	20R	1.5	20G	1.3	20B	1.6
30Y	1.1	30M	1.7	30C	1.4	30R	1.7	30G	1.4	30B	2.0
40Y	1.1	40M	1.9	40C	1.5	40R	1.9	40G	1.5	40B	2.4
50Y	1.1	50M	2.1	50C	1.6	50R	2.2	50G	1.7	50B	2.9

10 blue 20 blue

10 green 20 green

10 red 20 red

10 yellow 20 yellow

10 magenta 20 magenta

10 cyan 20 cyan

SLIDE COPYING

Slide copying is a useful, basic technique that can be used to copy important original transparencies, to correct mistakes, and even for special effects like combining images. While a colour negative is always used as a source for printed images, and never as an end-result, slides are often projected or displayed in sheets. While negatives spend most of their lives in protection and darkness, slides usually come in for handling. Hence, if you have only one original of a prized slide, it is a good idea to copy it. The copy can then be used in slide shows.

The simplest way of making a duplicate slide is to attach a translucent mount in front of your camera, using either extension rings or an exension bellows to give a 1:1 enlargement. The original slide is placed in front of the translucent frame, and a reliable light source aimed from behind, towards the camera. The camera's TTL meter will take care of the exposure of a normal original, but if the image is rather dark or light (you will have to judge this for yourself), increase or decrease the exposure accordingly. Electronic flash has a consistent colour.

A more sophisticated and convenient method is to use a slide copier. This is a more expensive piece of equipment, but if you intend to make copies regularly, it will give you more control. Consistency is the key to successful slide copying. Most slide copiers use flash as a light source.

You can copy originals onto regular colour slide film, but there will be an increase in contrast. This may actually improve some slides, particularly those taken under flat lighting. Strongly-lit images with a big contrast range between shadows and highlights will, however, suffer. There are two ways of overcoming this build up of contrast: one is to fog the film very slightly at the time of exposure, and for this, slide copiers usually have an attachment that leaks a small amount of light onto the film in the camera. This has the effect of opening up the shadows slightly without affecting the brighter areas. The

ABOVE Copying slides can be a creative as well as mechanical process. Ordinary images can be given a boost by either adjusting the exposure or using filters during copying. In this case, a green filter has been added to great effect.

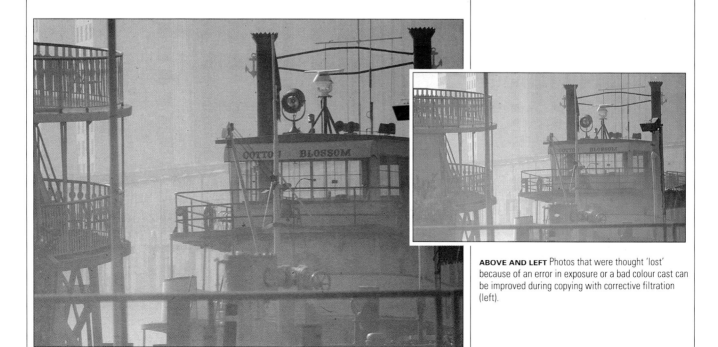

ABOVE AND LEFT Photos that were thought 'lost' because of an error in exposure or a bad colour cast can be improved during copying with corrective filtration (left).

second method is to reduce the development. Copying is most straightforward, however, if you use slide duplicating film, which is designed to keep contrast down.

As with colour printing, you will need to make exposure and filtration tests at the start. Use a 1B filter as a permanent part of the filter pack, then follow the recommendations that come with the slide duplicating film pack. Different batches of film need different sets of filters, so read the recommendations carefully when you buy new film.

Making a duplicate

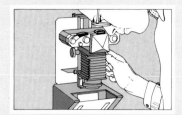

1 With the lens aperture wide open, and the transparency placed in the holder, adjust both the lens and camera positions until the image is correctly framed and focused.

2 Stop down the lens to the aperture previously selected by testing, and, with the photo-electric cell swung over the transparency, rotate the light control knob until the needle is zeroed.

3 According to the amount of fogging needed, select the light output from the contrast control unit by rotating the rear dial. With experience you can judge the best level for each original.

4 Swing the photo-electric cell away, switch the unit from modelling light to its flash exposure setting, and expose by pressing the camera's shutter release.

Slide copier

Scale showing magnification and exposure increases

Focusing track

Contrast control unit

Photo-electric cell

Sync lead

Bellows

45° glass

Transparency holder

Filter drawer

Light control knob

Open flash switch

Modelling light/flash exposure switch

Exposure indicator needle

COPYING PRINTS

Copying prints and any other flat illustration needs very little in the way of extra equipment, and once you have learned the very straightforward techniques, can be a useful addition to your repertoire of skills. It can be used, for example, to make a new negative from a colour print, and for copying paintings. There are just three important things to consider: lining up the camera so that it is straight on to the original being copied, lighting the picture evenly and without reflections, and keeping the colours the same.

◼ LINING UP THE IMAGE

The two easiest positions for copying are flat down onto a table or work surface, and face on to a wall. With a photographic print or other small original, the first position is easier, but a large painting is usually best left hanging on a wall. In either case, the camera must be on a tripod. One advantage of facing down is that you can use a spirit level on both the back of the camera and on the surface to make sure that both are aligned. Otherwise, compare the edges of the original being copied with the edges of the viewfinder frame. Look for evidence of 'keystoning', in which two of the sides seem to lean inwards – this shows that the camera is at an angle to the original. One of the most accurate methods is to place a small mirror flat against the original, and adjust the camera until you can see the lens reflected back exactly in the middle of the viewfinder.

◼ LIGHTING

Even lighting is important, and the best method of all is to place four lamps, one at each corner and at the same distance from the original. In practice, with small originals, two lamps work just as well. Aim each lamp towards the opposite side of the original rather than to the centre; this will avoid a hot spot in the middle. Test the evenness of the lighting by holding the tip of a pencil perpendicular to the centre; it should cast the same shadow on either side. To avoid reflections off the print or painting, keep the angle of the lamps shallow. The further back they are and closer to the camera, the more the risk of reflection, which will weaken the colour.

Vertical copying

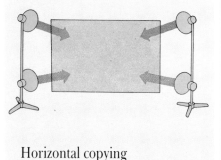

A horizontal arm keeps tripod legs out of the shot. A lamp at each corner (below) is the ideal light.

Horizontal copying

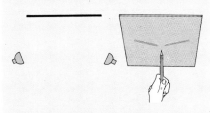

Using two lamps (above), a flat surface can be evenly lit by aiming each at the opposite edge. The strength of the two shadows cast by a pencil held up to the surface will show if the illumination is equal. Shade the camera lens from the direct lamp light with large pieces of card.

▌ COLOUR ACCURACY

As in copying slides, there are likely to be some variations in colour, as you are copying one set of dyes (on the original) onto another set (in the film). The best check, and one that can be used to make corrections when printing later, is to pin or tape alongside the original a swatch of standard colours, including a neutral grey. Professionals who copy paintings use a proprietary colour guide, which can be bought at some photographic stores.

LEFT AND FAR LEFT It's possible to copy more than photographs. To avoid reflections off the painting ruining the copy, keep the angle of the copying lights shallow.

BELOW A Kodak colour guide, which can help to keep original colours when printing a copy, particularly if the original is a painting.

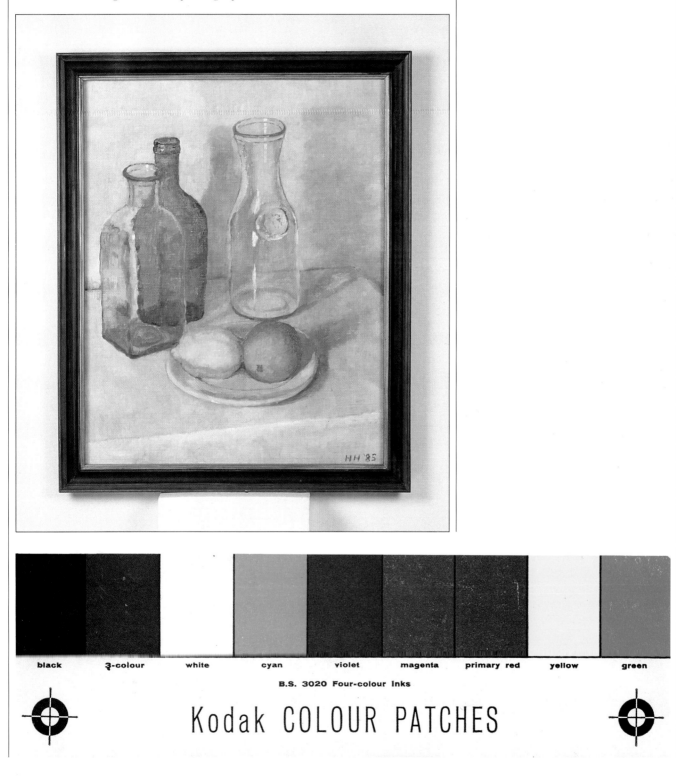

black 3-colour white cyan violet magenta primary red yellow green

B.S. 3020 Four-colour Inks

Kodak COLOUR PATCHES

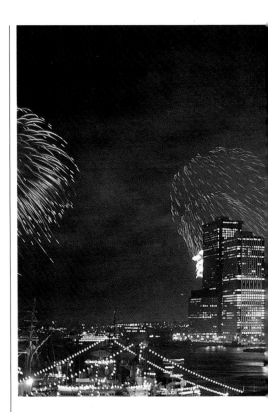

Fourth of July celebrations from Brooklyn Heights; taken using a tripod and with long exposure to capture the firework bursts.

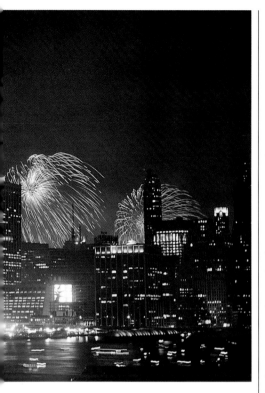

A C K N O W L E D G E M E N T S

The author and publishers of this book would like to thank the following for providing pictures and information:

Durst; Hoya Filters; Joba; Kodak; Minolta; Olympus; Pentax; Ricoh; Tom Shepherd and particularly Ballancroft Film and TV Equipment, and Jessop of Leicester Ltd. Special thanks are also due to Mark Payton.